IMAGES
of America

SAN FRANCISCO
JAZZ

IMAGES
of America

SAN FRANCISCO
JAZZ

Medea Isphording Bern

ARCADIA
PUBLISHING

Published by Arcadia Publishing
Charleston, South Carolina

Printed in the United States of America

Library of Congress Control Number: 2014954964

For all general information, please contact Arcadia Publishing:
Telephone 843-853-2070
Fax 843-853-0044
E-mail sales@arcadiapublishing.com
For customer service and orders:
Toll-Free 1-888-313-2665

Visit us on the Internet at www.arcadiapublishing.com

For my dad, whose record collection started me down this path decades ago. Thank you. In memory of Prentice "Pete" Douglas, who bestowed an appreciation for small-venue jazz upon my children and countless others during his 50-year career.

CONTENTS

ACKNOWLEDGMENTS

The musicians and fans who populate the San Francisco jazz community have opened their hearts and archives to assist in the creation of this volume.

It is impossible to overstate the generosity of those who contributed their time, stories, and memorabilia: Brian McMillen, a jazz photographer and now friend, opened his glittering archive of emotional and technically astute photographs of Bay Area musicians; William "Bill" Carter, clarinet player and board member of the San Francisco Traditional Jazz Foundation, provided additional observations about the local jazz ecosystem that allowed this book to be more than a mere recitation of facts; Pat Yankee and Marianne Kent shared tales about their early days on the road, their exploits, their triumphs, and their heartbreaks; Dick Salzman, a local vibraphone player who played in Dave Brubeck's band and hung out in Paul Desmond's basement, welcomed me to his hospital room to recount his experiences just two weeks before he passed away; Randall Kline, visionary founder of SFJAZZ, graciously answered my questions about how this nonprofit arts jewel in the city's crown came to be; and Jonathan Manton and Benjamin Bates, archivists of the Stanford Archive of Recorded Sound, were endlessly patient.

Thanks also go to Pete Douglas and Linda Goetz of the Douglas Beach House, Christine Harris of the Jazz Heritage Center, Barrett Shaver and Nora Trice at SFJAZZ, Herb Goodrich, Flicka McGurrin of Pier 23, Allen Houser, Karen Houser, Barbara Dane, Gary Kamiya, Jean Goldberg, Galer Barnes, Casey Stoll, Nelson Stoll, Derrick Bang, Scott Anthony, Jeff Ruetsche, Anne Zimmerman, and many others. Finally, thank you to my family, who supported me during this book's gestation.

INTRODUCTION

The first time I remember hearing a trumpet solo that propelled me out of my seat, I was six years old. Al Hirt's hirsute cheeks and wide grin called from the baby blue cover of his album *Cotton Candy*, on which he grips his trumpet as if it were a cone, a pink cloud of confection on top. I propped the album cover up in front of my red-and-white vinyl record player, pretending that Hirt was blowing his horn in appreciation of my sophisticated, interpretive dance steps. As Art Blakey said, "You don't have to be a musician to understand jazz. All you have to do is be able to feel."

It was something about a horn—the sensuous licks, the versatility, the way a horn player can deliver multiple octaves of emotion in a single phrase—that drew me in at first. Then, as I listened to other groups, largely traditional jazz standards from my parents' collection from their days working in New Orleans, the dialogue between the musicians started to intrigue me: how a saxophone player could play a few bars and the piano player would answer, with the drummer tapping his two cents. Then everyone is talking at once, the whole band shimmering with sound, playing as one. My young mind was just tuning in to the Beatles, on the cusp of total immersion in the Monkees, and shielded from the Rolling Stones by parents who did not quite grasp that the Stones were really Delta bluesmen, and discovering Al Hirt and jazz forever after informed my musical proclivities.

The first use of the term *jazz* in print occurs in conjunction with a 1913 article about the San Francisco Seals baseball team by Scoop Gleason. It was meant to convey a sense of pep, or spirit, and derives from the Irish word *teas*, pronounced "jass," which means "passionate" or "enthusiastic." In a column featured in the April 5 issue of the San Francisco bulletin that same year, Ernest Hopkins remarks on the onomatopoetic quality of the new word and wrote that "jazz is at home in a bar or a ballroom; it is a true American." And yet, the early pioneers of our unique American music, in its many iterations—from ragtime to Dixieland to bebop and beyond—felt constrained by the term. They believed that it was a moniker imposed by nonmusicians, mainly white, to identify any kind of nonclassical music. Duke Ellington said calling black music "jazz" was akin to using a four-letter word: "By and large, jazz always has been like the kind of man you wouldn't want your daughter to associate with. The word 'jazz' has been part of the problem."

Like all art forms, music is organic and subject to interpretation by its composers and its performers. The original ragtime blues that forms the foundation of jazz has taken on the patina of legions of musicians who added their own techniques and inspirations to craft a uniquely American sound. In the course of researching this book, I found that the history of the jazz scene in San Francisco is really many histories, overlapped, intertwined, branching out, and circling back. Musicians tour, so naturally, San Francisco's clubs and halls hosted the famous from near, like Dave Brubeck, and far, like Charlie Mingus. And many more musicians who started their careers here or adopted San Francisco as their home earned both fame and adoration, like Turk Murphy and Norma Teagarden.

The deep roots of jazz also spurred countless festivals, including the venerated Monterey Jazz Festival, which Jimmy Lyons founded in 1958 to support and showcase modern jazz music. Jazz festivals still dot the Bay Area cities and towns, ebbing and flowing, traditional jazz or Latin jazz or soul jazz.

The history of San Francisco's jazz music scene continues to be written today. Randall Kline started SFJAZZ in 1982. He produced shows in the city for decades before finally realizing his dream in 2013 and opening a performing arts center dedicated to jazz at the corner of Franklin and Fell Streets in the heart of the Civic Center. The SFJAZZ Center has quickly become the center of both contemporary and experimental jazz, presenting revered greats like saxophonist Wayne Shorter and vibraphonist Bobby Hutcherson as well as the brilliant teenagers who perform with the SFJAZZ High School All-Stars. The stories of these bright young men and women will make up the next chapters in the history of jazz in the Bay Area.

Whether you like your jazz served up traditional style, bounced with a little bebop, blinding hot or hep cat cool, the music that fires your soul has rumbled and roared through San Francisco, leaving a cascade of memories and paving the way for whatever sound the new generations will add to its sensual aural stew. What appears in these pages is merely a taste.

One

IN THE BEGINNING

Jazz music first appeared in San Francisco during the bawdy Barbary Coast years. Pacific Street between Kearny and Battery Streets formed the epicenter of all that was exciting, raucous, entertaining, and sometimes dangerous. Known as "Terrific Street," these blocks boasted clubs and dance halls like the Hippodrome, the Bear, Spider Kelly's, and the Thalia, each with marquees that drenched the night sky with electric light. Nimble, sometimes interracial ("black-and-tan") hoofers first danced the turkey trot. Sid LeProtti's So Different Jazz Band entertained locals and tourists, dignitaries and celebrities at Lew Purcell's So Different Saloon. Jelly Roll Morton entertained the hopeful and the hapless with piano rags at his Jupiter Club. All the joints jumped with music, dance, and an undercurrent of vice, a sort of unofficial West Coast Storyville.

The 1906 earthquake leveled and scorched large swaths of the city, including the Barbary Coast. Fate, a fortuitously placed hose, and a convenient wind shift spared Hotaling's, the Jackson Street distillery that kept saloons awash in spirits, inspiring an oft-quoted quip: "If as they say, God spanked the town for being over frisky, / Why did he burn the churches down / And spare Hotaling's whisky?"

"Terrific Street" bounced back quickly, buzzing again with cabarets, dance halls, and brothels just a few years after the quake. "Slummers," the offspring of the city's landed class, frequented the scene. When these privileged progeny were not dancing, proprietors offered them pricey balcony seats above the fray, a perfect spot for them to sip their cocktails and observe the entertainment (including fights sometimes staged by club owners) below.

Encouraged by a war on debauchery declared by the Hearst Corporation's editorial board, the board of police commissioners passed a resolution in September 1913 intended to snuff the fun from the Barbary Coast. Largely by outlawing dancing and other "vices," the declaration would give police another justification for rooting out prostitutes and hopheads. The California Legislature enacted the Red Light Abatement Act in 1914. This galvanized the local district attorney's office to launch a full-scale attack against the bawdy businesses of the Barbary Coast. Property owners

rebelled and challenged the law in court. World War I broke out the same year. The bands played, and the Barbary Coast sputtered on. In 1917, the state supreme court dealt a blow to those who challenged the red-light law, affirming its legality. The police cut off circulation to the heart of San Francisco's cradle of vice in February 1917. The fight against fun would ultimately close 83 brothels and 40 saloons. Then arrived Prohibition. With the venues shut down and the demise of the Jupiter in 1921, musicians moved on, seeking more fertile performing and recording ground in Los Angeles and points east.

It would take another world war to bring jazz back to San Francisco with its characteristic gusto and flair. The Oakland and Alameda shipyards mobilized to build armaments for a military woefully underprepared to battle the well-financed and well-armed Axis forces. In the 1940s, the decades-dark Barbary Coast flickered with a brief renaissance as the International Settlement. Across town, jazz thundered in and lit up the Fillmore District.

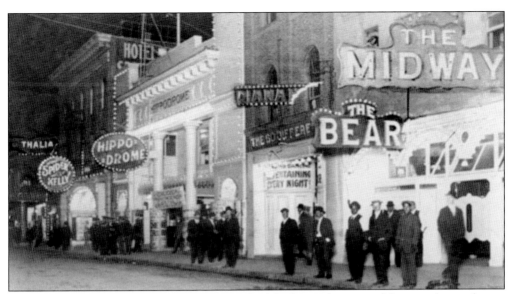

On Pacific Street around 1910, a gauntlet of nightclubs featured music and fun into the wee hours. Civic leaders, supported by the editors of the *San Francisco Examiner*, declared war on the vice rampant here in 1913. The owner of the Thalia (last marquee visible) was arrested and found guilty of running a "disorderly house" in November 1921. Pacific Street and other northeastern parts of the Barbary Coast now form part of the Jackson Square Historic District. (Courtesy of San Francisco Traditional Jazz Foundation.)

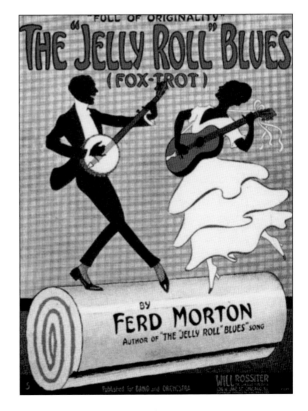

At right is the sheet music cover for "The 'Jelly Roll' Blues" by Ferd Morton. Better known as "Jelly Roll Morton," Ferdinand Joseph LaMothe (1890–1941) is remembered both for being the first jazz arranger and for his performing prowess. He published the first jazz composition, usually called "Jelly Roll Blues," in 1915. (Courtesy of Library of Congress.)

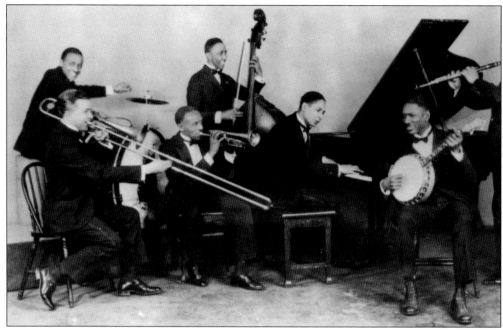

Jelly Roll Morton and His Red Hot Peppers toured the United States from coast to coast. Band members included fellow New Orleans musicians such as Kid Ory, Barney Bigard, Johnny Dodds, and Andrew Hilaire. (San Francisco Traditional Jazz Foundation, ARS.0030. Courtesy of the Stanford Archive of Recorded Sound, Stanford University Libraries.)

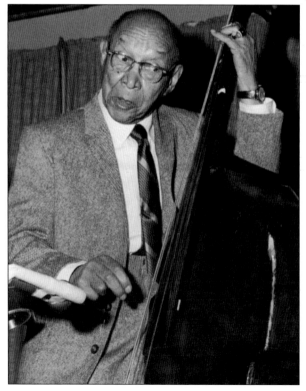

Bassist and tuba player George Murphy "Pops" Foster (1892–1969) first performed in his native New Orleans in 1906. He performed with Jelly Roll Morton, Louis Armstrong, and Kid Ory. Foster spent the years from 1956 to 1961 in San Francisco playing with Earl "Fatha" Hines, and he eventually died here. (Courtesy of San Francisco Traditional Jazz Foundation, the "Pops" Foster Collection.)

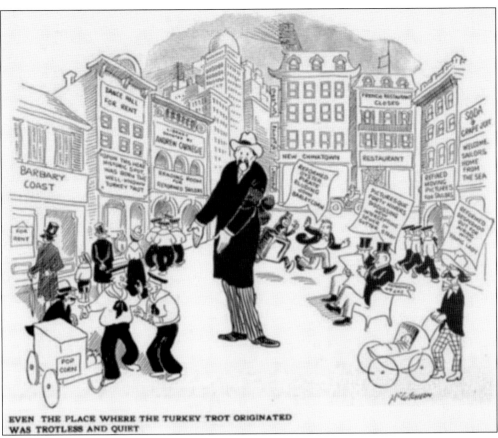

EVEN THE PLACE WHERE THE TURKEY TROT ORIGINATED
WAS TROTLESS AND QUIET

This cartoon reflects the city's early attempts to shut down Terrific Street, where the popular turkey trot dance was born. (Courtesy of *Roughing It De Luxe* by Irvin S. Cobb and John T. McCutcheon.)

Sid LeProtti stands at the entrance to the International Settlement on Pacific Street between Kearny and Montgomery Streets. Part of the original Barbary Coast underwent a revival in the 1940s, briefly luring back club owners and patrons. (San Francisco Traditional Jazz Foundation, ARS.0030. Courtesy of the Stanford Archive of Recorded Sound, Stanford University Libraries.)

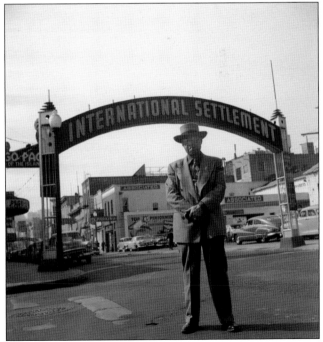

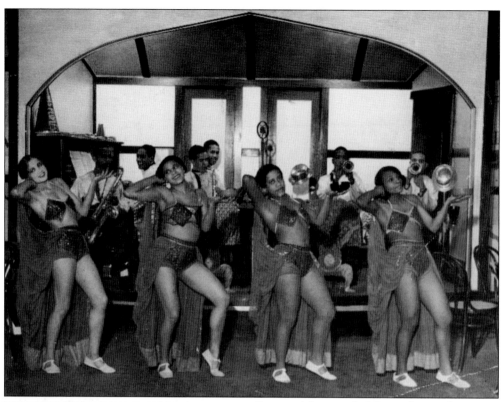

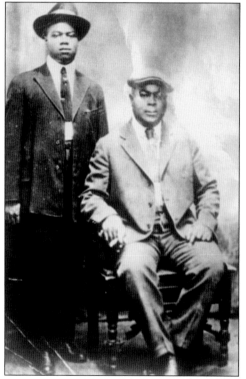

Song and dance ruled the nights on the Barbary Coast. This photograph depicts dancers Billy Davis, Helen Ross, and two unidentified girls, with Elmer Clayborn on saxophone, Wes Peoples on piano, Bob Banfield on saxophone, Eddie Alley on drums, Jimmie Brownley on trumpet, and ? Belvin on trumpet. (Courtesy of San Francisco Traditional Jazz Foundation, the "Pops" Foster Collection.)

Louis Armstrong (left) and Joe "King" Oliver pose for a photograph in the 1920s. Their influence on San Francisco's jazz musicians—particularly Lu Watters, Turk Murphy, and members of their bands—is notable. (San Francisco Traditional Jazz Foundation, ARS.0030. Courtesy of the Stanford Archive of Recorded Sound, Stanford University Libraries.)

Popular trombone player Edward "Kid" Ory is photographed with his daughter Babette at their San Anselmo home in 1956. During his career, the New Orleans bandleader shared the stage with Jelly Roll Morton, Louis Armstrong, Joe "King" Oliver, and Sidney Bechet. Ory moved to Los Angeles in 1919 and formed the Kid Ory Creole Orchestra. In 1922, his band became New Orleans's first all–African American band to record. He suspended his band during the Depression to run a successful chicken farm, but he resumed performing afterward. With his original, reunited band and its hot jazz sound, Ory helped launch the West Coast revival that inspired San Francisco musicians. (Photograph by Robert Brunner; San Francisco Traditional Jazz Foundation, ARS.0030. Courtesy of the Stanford Archive of Recorded Sound, Stanford University Libraries.)

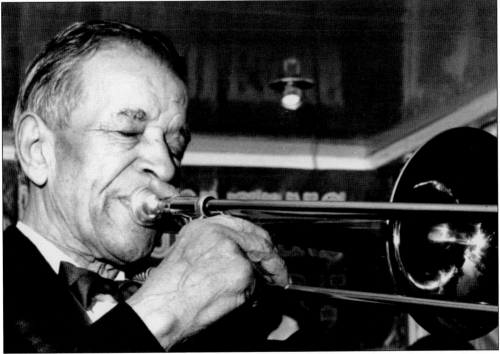

Kid Ory is shown in action in 1965. Ory was best known for his tailgate trombone style, in which he played the rhythmic bass line underneath the band's trumpet and clarinet. Ory also owned a nightclub on the Embarcadero called On the Levee (formerly the Tin Angel) across the street from Pier 23. (Photograph by Edward Lawless; San Francisco Traditional Jazz Foundation, ARS.0030. Courtesy of the Stanford Archive of Recorded Sound, Stanford University Libraries.)

At left is the sheet music for "Harlem Rag," an 1897 ragtime piece by Tom Turpin. (San Francisco Traditional Jazz Foundation, ARS.0030. Courtesy of the Stanford Archive of Recorded Sound, Stanford University Libraries.)

A group of "jass" musicians advertises its sound in an unconventional way, verifying the notion that jazz music was originally on the fringes of polite society. (San Francisco Traditional Jazz Foundation, ARS.0030. Courtesy of the Stanford Archive of Recorded Sound, Stanford University Libraries.)

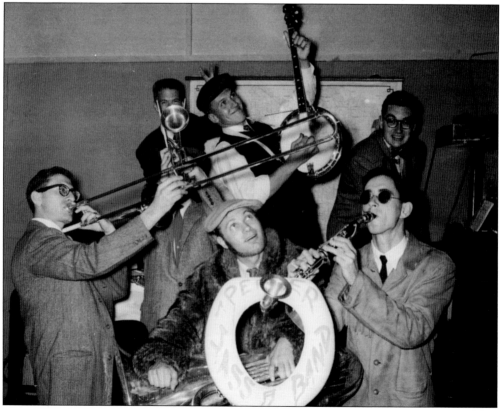

Two

THE FILLMORE YEARS

The Fillmore District came into its own after the 1906 earthquake decimated the seat of government and most of San Francisco's other commercial districts. Most African Americans lived here and in the adjacent Western Addition because of racial covenants restricting their rights to live and own property in other parts of town. The district itself was a racial melting pot, populated by Japanese, Russians, Filipinos, and Mexicans, and by some accounts the most racially diverse west of the Mississippi. The only two hotels that accommodated African Americans in San Francisco—Manor Plaza Hotel at 930 Fillmore between McAllister and Fulton Streets, and the Booker T. Washington Hotel on Ellis Street between Fillmore and Webster Streets—were contained within the Fillmore's 20 blocks. The other option for lodging for visiting African American musicians was in a rooming house; blacks were not welcome to stay downtown, a line drawn at the eastern edge of uptown by Van Ness Avenue.

When the Japanese bombed Pearl Harbor and the large Japanese population of the Fillmore was relocated to internment camps, empty homes and business were filled by newcomers, mostly African American Southerners from Texas and Louisiana, who had headed west to work in the shipyards. This influx of new residents, and the concurrent need for enterprises to support them, caused a surge in black-owned businesses in the Fillmore.

White cabarets played a commercially safe mixture of standards, top ten tunes, tangos, rumbas, waltzes, and polkas, but the real action, the bebop big deal, buzzed in the Fillmore.

Ladies and gentlemen, dressed to impress, started their nights in one of more than a dozen hopping clubs that lined the parallel Fillmore and Divisadero Streets and the spaces between. Popular venues were so thick on Divisadero Street that a night on the town here demanded the sartorially superior couples to strike out on a "Divisadero Stroll" and hit as many clubs as they might.

Jack's Tavern, also called "Jack's of Sutter" for its Sutter Street location, was the first African American–owned club in the Fillmore, opened in 1933. Local bassist Vernon Alley performed here;

Lionel Hampton discovered him during a performance in 1939. The club served as a springboard for many musicians of the era.

Jimbo's Bop City (1690 Post Street at Buchanan Street) anchored the scene. Originally a Japanese-owned drugstore, the lavender Queen Anne Victorian building briefly housed Slim Gaillard's club Vout City until its owner, Charles Sullivan, "the Mayor of Fillmore Street," rented it to a fellow African American businessman. John "Jimbo" Edwards, known as "the Mayor of Post Street," owned a car dealership before his historic turn as the owner of one of the most important clubs in San Francisco. Jimbo's started as a waffle shop, but when the tough but affable Jimbo allowed musicians to take over the back room for jam sessions, he repurposed the house. Jimbo's Bop City served as an incubator where everyone from John Coltrane to Charlie Parker appeared. Those who aspired to a career in jazz yearned to play Bop City.

Local saxophone legend John Handy sat in at Bop City soon after it opened as a music club in 1950. He was an 18-year-old just beginning to taste the sweet honey in his horn. Handy remembers Bop City and the iconic Jimbo as a scene and a leader, respectively, both worthy of reverence and awe. Handy also experienced his share of early-career frustration at Bop City: "There was a blind pianist in the house band, the only person Jimbo allowed to play solo. If a singer was singing, this guy [Freddie Gambrel, who would change his name to Federico Cervantes in 1965] would play the wrong notes." Of course, this is one man's recollection; trumpet player Allen Houser recalls Cervantes as a professional, "a virtuoso pianist and a high note (read "screech") trumpet player who made his own eccentric mouthpieces . . . known . . . for playing difficult tunes, such as "Along Came Betty" through the keys (all 12 of them!)." When Gambrel/Cervantes passed away in 2004, many described his death as a "loss for the world."

Sonny Buxton, another local star, drummer, radio personality and owner of the Milestone Club in the 1960s, played Bop City three times during its run. Jimbo's hours of operation ran from 2:00 a.m. to 6:00 a.m. sharp, and Buxton recalled that "at 6 am, Jimbo would put up the house lights and tell the band to stop" and that he (Buxton) "never did finish a gig there."

Drummer and St. Louis native William "Smiley" Winters nurtured his share of young musicians in this jazz incubator as well, including a shy but diligent Handy. Winters also nudged a reluctant Pharoah Sanders, pushing him to play with Coltrane when Coltrane extended the offer. With 10 children of his own to support, Winters became a fixture at San Francisco's finest clubs, playing with Miles Davis, Sonny Stitt, Charlie "Bird" Parker, and the other greats who enjoyed lengthy engagements or who were simply passing through. Of playing with Bird, Winters said, "All you had to do was follow Bird. I sounded the best I ever did with him."

Bop City reigned supreme among after-hours clubs for 15 years, until redevelopment paved it over in 1965.

The cavernous Primalon Ballroom (1223 Fillmore Street), owned by James and Carrie McCoy from 1949 until 1951, spent its weekdays as a roller-skating rink and its weekends as a nightclub. The McCoys also owned the Manor Plaza Hotel (formerly the Edison, which was race restricted), where the music played in the basement during the 1950s. It was at the Primalon in 1954 that, according to one account, a bold 14-year-old named Jamesetta Hawkins of the rare all-girl doo-wop band the Creolettes, collared bandleader Johnny Otis and asked him for an audition. Otis was so impressed that he arranged for the band to record Jamesetta's song "Roll With Me Henry" in Los Angeles. Harnessing Jamesetta's nickname, he renamed the band "Peaches" and urged the teen to change her name to Etta James. Another version claims Jamesetta marched up to Otis's Fillmore hotel room, flung open the door, walked into the bathroom, and sang into the tile. Either way, Otis whisked the teens off to Los Angeles the same night and helped Etta James and the Peaches land their first recording contract with Modern Records.

Redevelopment would rend this "Harlem of the West," scattering the memory of the clubs and the talent of the musicians like seeds to other parts of the city, to Oakland and Berkeley or out of the area entirely. City blocks of buildings were razed or relocated, and the Fillmore lost its soul to the snarling Cerberus of progress. But this is San Francisco, where nothing is impossible and anyone who arrives armed with determination and a glimmer of a dream has a shot at success.

The former Manor Plaza Hotel at 930 Fillmore is now a church. (Courtesy of Harley Bruce Photography.)

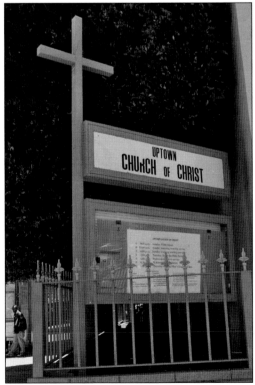

This is signage for Uptown Church of Christ at former site of the Manor Plaza. (Courtesy of Harley Bruce Photography.)

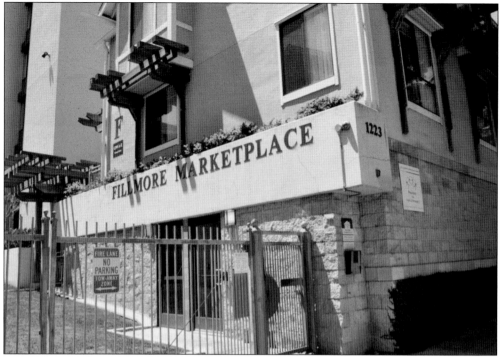

The former Booker T. Washington Hotel property is now the Fillmore Marketplace. (Courtesy of Harley Bruce Photography.)

Apartment buildings replaced the Booker T. Washington Hotel on Ellis Street between Fillmore and Webster Streets. (Courtesy of Harley Bruce Photography.)

One of the few historic buildings to survive redevelopment, Jimbo's Bop City was moved to its current location at 1712–1716 Fillmore Street. Until it was sold in June 2014, the building housed the nation's oldest African American–owned bookstore, Marcus Books, originally called Success Book Store. Owners Julian and Raye Richardson changed its name to reflect their appreciation and respect for the philosophy of Marcus Garvey. (Courtesy of Harley Bruce Photography.)

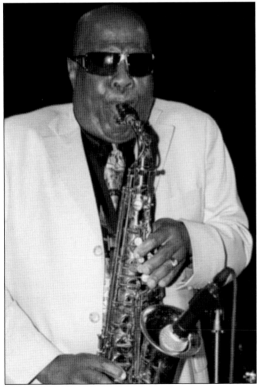

John Handy (born in 1933) played Jimbo's with the incomparable Art Tatum when still a teenager. Given Handy's commitment to his craft, he no doubt absorbed Tatum's credo: "Just remember there is no such thing as a wrong note. What makes it wrong is where you don't know where to go after that one." Handy would play many gigs at Bop City with his own eventual quintet, "which was 3/5 white," and in jam sessions with his idol, saxophone player Pony Poindexter, who had been a student at the same Oakland high school a few years before Handy. (Courtesy of *African Americans of San Francisco* by Jan Batiste Adkins, per Jazz Heritage Center of San Francisco.)

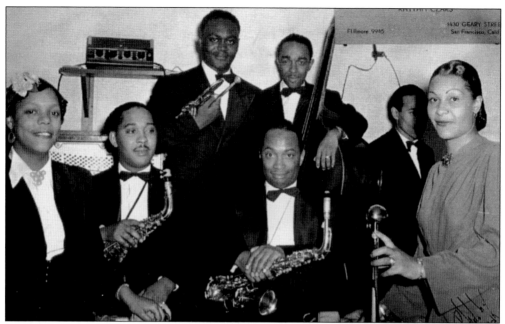

Johnnie Ingram and His Bass and Rhythm Czars performed regularly in the Fillmore; they are pictured here at Jack's Tavern. From left to right, the musicians are Betty Allen, piano; Willie James, saxophone; McKissic London Holmes, trumpet; Charles Whitfield, saxophone; Johnnie Ingram, bass; Delmar Smith, trumpet; and Evelyn Myers, vocals. Ingram also appeared at the Subway Nightclub in the International Settlement and led the house band at the California Theater Club. (Courtesy of *San Francisco's Fillmore District* by Robert F. Oaks, per Johnnie Ingram.)

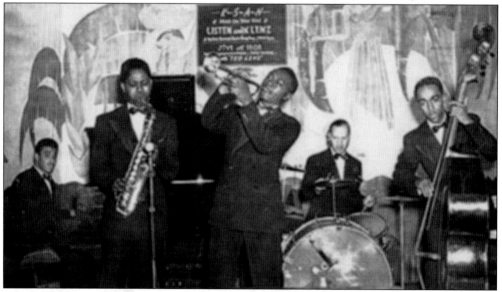

Johnnie Ingram is pictured at the Subway Club in 1944. The North Beach haunt was owned by Wesley Johnson Sr., who would later open popular clubs in the Fillmore that featured stars like Billie Holliday. Musicians in this photograph are David Richards on piano, John Henton on saxophone, McKissic London Holmes on trumpet, and Ingram on bass. (Courtesy of *San Francisco's Fillmore District* by Robert F. Oaks, per Johnnie Ingram.)

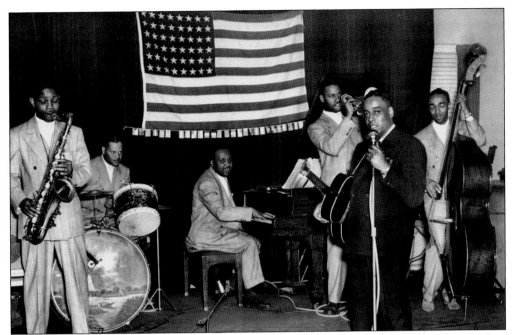

Johnnie Ingram performs in 1950 at the at the California Theater Club with bandmates Nate Christ on guitar and at the microphone, John Henton on saxophone, Norville Maxey on drums, Lee Dedman on piano, and Otto Sampson on trumpet. (Courtesy of *San Francisco's Fillmore District* by Robert F. Oaks, per Johnnie Ingram.)

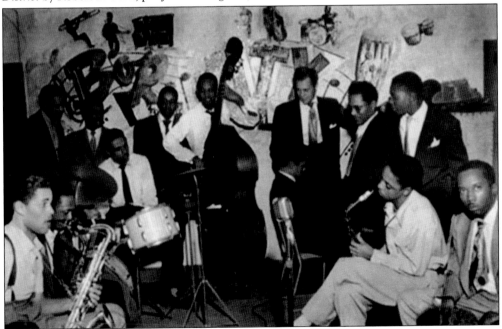

Trumpet and piano player Frank Fisher (born in 1926) and company jam during a late-night session at Bop City. Fisher served in Germany during World War II and arrived in the Bay Area afterward to work in aviation electronics at the Alameda Naval Air Station. (Courtesy of *African Americans of San Francisco* by Jan Batiste Adkins, per Frank Fisher.)

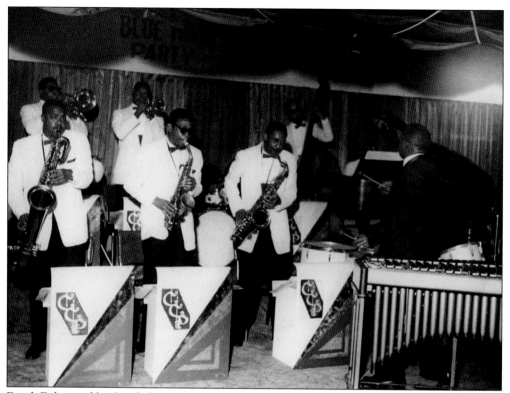

Frank Fisher and his band play a Blue Monday Party. Local jazz diva Denise Perrier recorded her own Blue Monday Party (a jam or other concert meant to cure the Monday blues) at contemporary jazz venue Yoshi's in 2004. (Courtesy of *African Americans of San Francisco* by Jan Batiste Adkin's, per Frank Fisher.)

Frank Fisher still composes music today and continues to perform with the 19-piece Junius Courtney Big Band and other Bay Area groups. (Courtesy of *African Americans of San Francisco* by Jan Batiste Adkin's, per Frank Fisher.)

Yoshi's, a club one block from both the Marcus Books building and the former site of the Primalon Ballroom, delivers a healthy helping of jazz along with funk, R & B, and blues acts. It shares the premises with San Francisco's Jazz Heritage Center. (Courtesy of Harley Bruce Photography.)

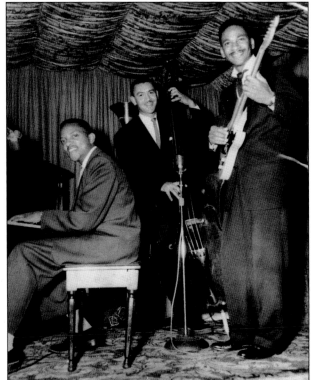

Frank J. Jackson (born in 1925), a swinging jazz pianist and vocalist, has led this and other groups in San Francisco since 1942. The Fillmore Jazz District recognized Jackson as a Heritage Pioneer Jazz Legend in 2005. (Courtesy of *African Americans of San Francisco* by Jan Batiste Adkin's, per the Frank Jackson Collection.)

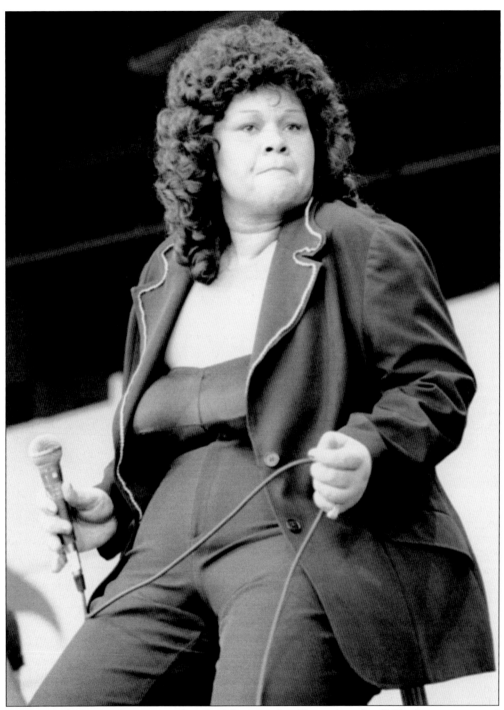

Etta James (1938–2012) is pictured at the Monterey Jazz Festival in the 1980s. James impressed audiences for decades with her contralto versatility, a powerful voice adept at singing jazz, doo-wop, R & B, and straight blues. She holds spots in the Blues, Rockabilly, Rock and Roll, and Grammy Halls of Fame. James and her mentor, Johnny Otis (né Veliotes), died during the same week in January 2012. She was 73; he was 90. (Courtesy of Brian McMillen.)

Three

YERBA BUENA JAZZ BAND AND THE TRADITIONAL JAZZ REVIVAL

Around a dimly lit corner from the venerable Palace Hotel, 50 feet off Market Street, the Dawn Club's hot pink neon crown blazed over the awning at 20 Annie Street. The marquee heralded Lu Watters's jazz band and the pleasures that awaited down the long flight of stairs inside. Watters installed his righteous Yerba Buena Jazz Band (YBJB) here in December 1939, moving the band from its birthplace at the Big Bear Tavern, an Oakland roadhouse. The band appeared with sponsorship by the Hot Jazz Society of San Francisco, a cousin of the seminal Le Jazz Hot club in Paris, a group dedicated to promoting the traditional jazz sound. The Dawn Club's motto was "No Tune Played Written After 1929."

A former Prohibition-era speakeasy, the Dawn Club, with its brass rail and twirl-worthy dance floor, boasted the longest bar in San Francisco. The YBJB performed for cocktail-sipping jazz lovers here four nights a week, with a break for military service, until 1947.

The YBJB and other bands attracted regulars, tourists, college students, and budding teenaged jazz musicians eager to dwell among these masters of the craft. When filming in town, even world-weary movie stars flocked to Dawn Club's cellar for a taste of San Francisco's spin on the New Orleans sound.

Watters on cornet and Turk Murphy on trombone anchored the ensemble band that lived to revive traditional jazz, the roots jazz that tapped west from New Orleans, the sizzling jazz that crooked its finger and beckoned all who listened to their feet. Bob Scobey on cornet and Ellis Horn on clarinet blew the joint into a frenzy with original tunes inspired by local characters, such as "Emperor Norton's Hunch," or a tight, bouncy version of King Oliver's "Canal Street Blues." Wally Rose on piano, Bill Dart on drums, Dick Lammi on tuba, and Clancy Hayes on banjo brought rollicking ragtime (noted for its syncopated, or "ragged" beat) back to San Francisco.

World War II split the band apart. Watters, Scobey, Murphy, and Rose left to serve the war effort; others stayed behind and performed at the Dawn Club. Ellis Horne and Clancy Hayes formed the YBJB wartime core, joined by musicians such as Burt Bales, Bob Helm, Russ Bennett,

Bill Bardin, Squire Girsback, and Benny Strickler. While aboard his troop ship, the SS *Antigua*, Watters arranged a number of compositions, including "Antigua Blues." Weary of the slick, orchestrated swing sound with its foxtrots and tangos, Watters constructed his original and cover tunes with traditional, two-beat New Orleans style. A horn player since age 11 and a lover of the heavy brass sound that is the hallmark of traditional jazz, he wrote music accordingly. Since the twang of the banjo figured prominently in Delta music, he wrote that in too. The YBJB offered San Franciscans jazz music that sprang from that gumbo of New Orleans blues and jazz, a harbor from the overly commercial, antiseptic tide of big-band swing.

In 1946, after their return from the war, Lu Watters and the YBJB played the Dawn Club for another two years before Watters relocated the band to Hambone Kelly's across the bay in El Cerrito. Two and half years later, Watters closed Kelly's and dissolved the band. A stint in college and a second career as a chef occupied his time until the early 1960s reunited him with Turk Murphy for a series of antinuclear concerts in Northern California. He recorded a single album, then retired again. Though the band played together a mere 12 years, its 1941 recordings on the Jazz Man label are considered among the most influential in jazz history for their impact on the revival of the New Orleans sound.

After the YBJB members parted ways, Bob Scobey formed a popular band in the same jazz tradition, Bob Scobey's Frisco Band. The band performed as a house band for Victor and Roxie's from 1950 until 1953. Scobey toured and recorded for several years, often joined by Clancy Hayes on banjo and vocals, and he ultimately moved to Chicago to open Club Bourbon Street in 1959.

Turk Murphy also formed his own band after the split. Murphy would remain a fixture in the San Francisco traditional jazz scene for another nearly four decades. Bandleader, composer, club owner, and ambassador for traditional jazz, Murphy was just getting started.

The Dawn Club, the first home of Lu Watters and his Yerba Buena Jazz Band, sat at 20 Annie Street behind the Palace Hotel. (San Francisco Traditional Jazz Foundation, ARS.0030. Courtesy of the Stanford Archive of Recorded Sound, Stanford University Libraries.)

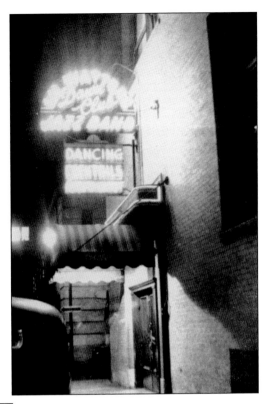

Today, Annie Street appears as another San Francisco urban canyon. (Courtesy of Harley Bruce Photography.)

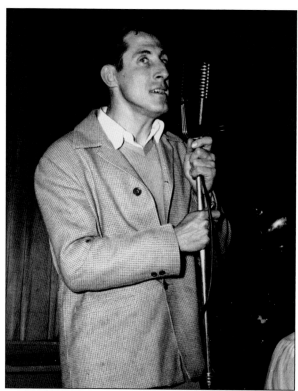

Harry Mordecai, typically featured on the banjo, takes a turn at the microphone. Other YBJB banjo pickers included Clancy Hayes, Pat Patton, and Russ Bennett. (San Francisco Traditional Jazz Foundation, ARS.0030. Courtesy of the Stanford Archive of Recorded Sound, Stanford University Libraries.)

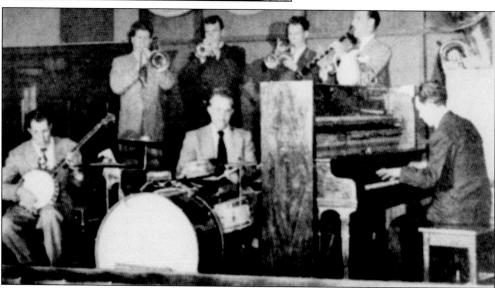

This image of Lu Watters (1911–1989) and the YBJB features, from left to right, (first row, seated) Harry Mordecai, Bill Dart, and Wally Rose; (second row, standing) Turk Murphy, Watters, Bob Scobey, Bob Helm, and Dick Lammi. The YBJB disbanded during World War II and regrouped afterward. It would play the Dawn Club until Murphy and Scobey split to form their own bands in 1948. Watters, a Santa Cruz native, retired from music in 1957 and pursued a degree in geology. (San Francisco Traditional Jazz Foundation, ARS.0030. Courtesy of the Stanford Archive of Recorded Sound, Stanford University Libraries.)

HERB CAEN
It's News to Me

What Is San Francisco?

WEDNESDAY, MAY 1, 1946

It's the pageant of transportation you see from Telegraph Hill—the Belt Line railroad inching along, trucks rattling around the Embarcadero, ships poking their noses into piers, aircraft making tiny marks in the sky.…. It's the thump-thump-thump of New Orleans rhythm oozing out from that alley cellar called The Dawn Club—where Lu Watters and his jazz band turn the musical clock back to 1908 as a banjo plunks tinny counterpoint. . . . It's the grim, glum outer stretches of the Mission, peopled by San Franciscans who've never crossed Market Street—people to whom Nob Hill is as far distant as Everest and no more inviting. . . . It's the bright, hyperthyroid show windows of automobile Row, displaying tantalizing wares which you may only stare at and maybe touch—making you feel like an urchin with his nose pressed to the pane.…

San Francisco's three-dot chronicler Herb Caen, the "voice and conscience of San Francisco," mentions Lu Watters and his jazz band's Dawn Club performances as being integral to the soul of San Francisco in his May 1946 column. The column ran daily, except Saturday, then ran five days a week from 1990 until illness forced Caen to write only periodically. It appeared in the *San Francisco Chronicle* for nearly 60 years. (San Francisco Traditional Jazz Foundation, ARS.0030. Courtesy of the Stanford Archive of Recorded Sound, Stanford University Libraries.)

31

This advertisement for the Melody Sales Company lists all of the Lu Watters Jazz Band recordings offered by West Coast Recordings. Note the two Annie Street tunes, a tribute to the Dawn Club's Annie Street location, and Emperor Norton's Hunch, named after one of San Francisco's more colorful characters, an eccentric Englishman named Joshua Abraham who proclaimed himself "Emperor of these United States" and went bankrupt speculating in Peruvian rice. (San Francisco Traditional Jazz Foundation, ARS.0030. Courtesy of the Stanford Archive of Recorded Sound, Stanford University Libraries.)

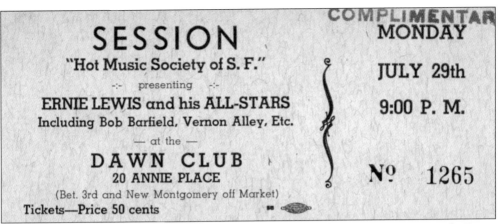

This is a ticket for a Hot Music Society performance by Ernie Lewis and his All-Stars at the Dawn Club. Band bassist Vernon Alley, whose first exposure to Jelly Roll Morton inspired him to a life as a jazz musician, also played with Saunders King, Lionel Hampton, and Count Basie. He remained a local jazz favorite throughout his life. (San Francisco Traditional Jazz Foundation, ARS.0030. Courtesy of the Stanford Archive of Recorded Sound, Stanford University Libraries.)

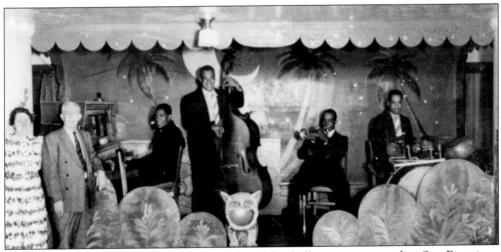

Vernon Alley (1915–2004), bassist and track and football star, was revered in San Francisco, known for his dedication to his craft as well as for his work with the arts and with human rights causes. He is remembered for integrating the musician's union locals, which had been segregated for decades prior to the 1960 merger. An alley near 200 Brannan Street was named for him in 2004. (San Francisco Traditional Jazz Foundation, ARS.0030. Courtesy of the Stanford Archive of Recorded Sound, Stanford University Libraries.)

"SIXTH SESSION,,
"Hot" Music Society of S· F.
VERNON ALLEY and His Boys

Acquatic Park Casino
FOOT OF POLK STREET

**MONDAY
MAY 20, 9 P. M.**
Tickets 40c
Members with Paid Up
Cards Free.
Members of Local 6
25c with Book

N.º 1029

Hot Music Society of San Francisco sponsored Vernon Alley and His Boys for a bayside concert at Acquatic (*sic*) Park Casino. The casino, designed to resemble a gleaming battleship, faltered soon after its opening in 1939. A decade later, Karl Kortum proposed opening a maritime museum on the site. It opened two years later and remains an important repository of artifacts that illustrate San Francisco's maritime culture and traditions. (San Francisco Traditional Jazz Foundation, ARS.0030. Courtesy of the Stanford Archive of Recorded Sound, Stanford University Libraries.)

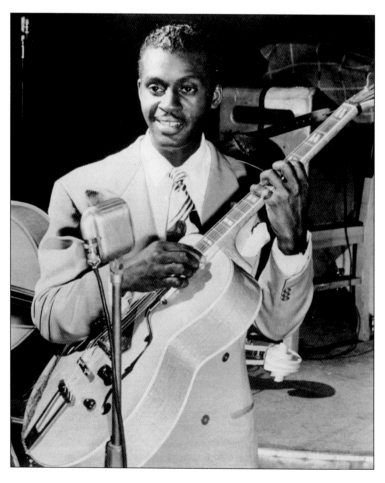

Saunders Samuel King (1909–2000), originally from Louisiana, released his first album, *S.K. Blues*, on Dave Rosenbaum's local Rhythm Recordings in 1942. King and his sextet were popular in and around San Francisco in the 1940s. He cut his final record as leader of Saunders King Rhythm in 1961. (Courtesy of *African Americans of San Francisco* by Jan Batiste Adkins, per the King family.)

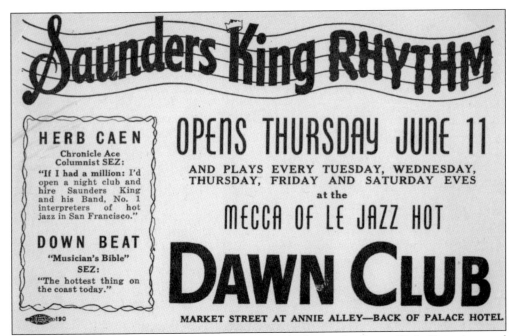

This notice is for a performance by Saunders King Rhythm at the Dawn Club. King pioneered the electric blues-guitar method that later influenced T-Bone Walker. He recorded with son-in-law Carlos Santana on *Oneness* in 1979, his first musical foray since his retirement in 1961. (San Francisco Traditional Jazz Foundation, ARS.0030. Courtesy of the Stanford Archive of Recorded Sound, Stanford University Libraries.)

This Rhythm Recordings record features King and his band performing "Jive at Eleven Five," composed by King and Bob Barfield. (San Francisco Traditional Jazz Foundation, ARS.0030. Courtesy of the Stanford Archive of Recorded Sound, Stanford University Libraries.)

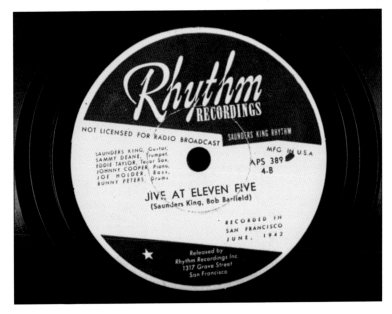

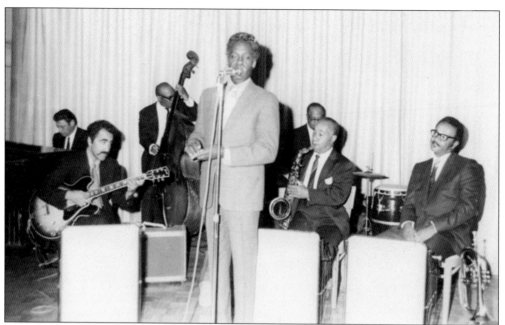

Saunders King and his band are pictured at the Backstage with Johnny Cooper on piano, Joe Holder on bass, Bernard "Bunny" Peters on drums, Eddie Taylor on tenor saxophone, and Sammy Deane on trumpet. (Courtesy of *African Americans of San Francisco* by Jan Batiste Adkins, per the King family.)

Saunders King Rhythm
"S.F.'s greatest interpreter of Swing"— HERB CAEN

•

ONE NIGHT ONLY

CIRQUE ROOM
FAIRMONT HOTEL

MONDAY • JUNE 22ND

Phone DOuglas 8800
NO COVER CHARGE **FOR RESERVATIONS**

Here is a notice of performance by Saunders King at the famed Fairmont Hotel's Cirque Room. Herb Caen called King the city's "Greatest Interpreter of Swing." (San Francisco Traditional Jazz Foundation, ARS.0030. Courtesy of the Stanford Archive of Recorded Sound, Stanford University Libraries.)

This 1950 photograph of the Pole Cats features, from left to right, Bob Hoskins, Howard Wood, Ellis Horne, Bunnie O'Brien, Dick Oxtot, K.O. Eckland, and Bob Bissonnette. (San Francisco Traditional Jazz Foundation, ARS.0030. Courtesy of the Stanford Archive of Recorded Sound, Stanford University Libraries.)

```
           BAYSIDE JAZZ SOCIETY
               presents a
       SATURDAY  NIGHT  SESSION
              with the
       POLE CATS
   Dick Oxtot, cornet         K.O. Eckland, piano
   Bunky Colman, clarinet   Bob Bissonette, banjo
   Howard Wood, trombone       Bob Hoskins, bass
             Bunnie O'Brien, drums
                  at
   JENNY LIND HALL  ——  2229 Telegraph Ave., Oakland
          December 2 from 9 to 1
   Admission $1.50                    Refreshments
```

This ticket is for a performance by the Pole Cats, featuring Dick Oxtot on cornet, at Jenny Lind Hall in Oakland. Richard Agee "Dick" Oxtot (1918–2001) performed with the YBJB, Bunk Johnson, Barbara Dane, and many others during his decades-long career. Oxtot fostered Dane's singing career along with those of many other female talents. Before the launch of her career as a rock star, Janis Joplin wrote and recorded "Mary Jane" with Oxtot and his band. Bayside Jazz Society was one of a number of affinity groups dedicated to promoting and presenting live traditional jazz music. (San Francisco Traditional Jazz Foundation, ARS.0030. Courtesy of the Stanford Archive of Recorded Sound, Stanford University Libraries.)

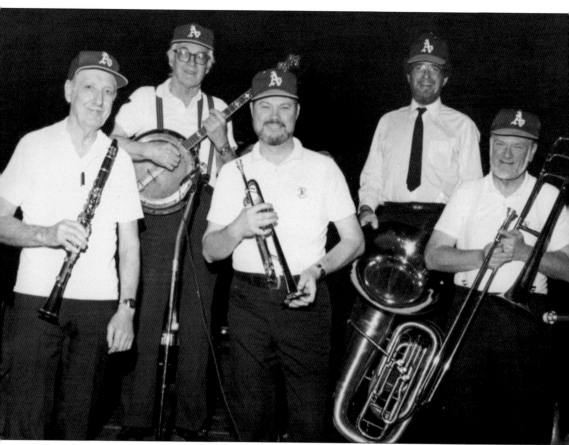

Seen here on banjo, Oxtot was also a regular with Bob Mielke in the Swinging A's jazz band, which entertained fans of the Oakland Athletics baseball team for years. Also featured here are traditional jazz favorites Helm (far left), Moore (second from right) and Mielke (far right). An unidentified musician friend stands at center. (Photograph by Edward Lawless; San Francisco Traditional Jazz Foundation, ARS.0030. Courtesy of the Stanford Archive of Recorded Sound, Stanford University Libraries.)

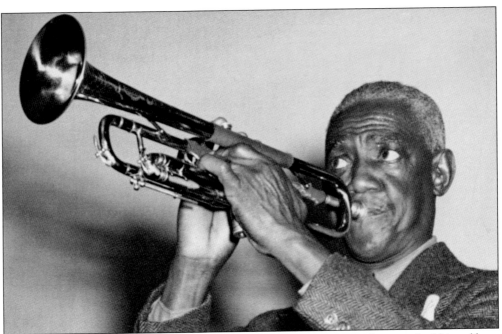

Gary "Bunk" Johnson (1879 or 1889–1949) hailed from Louisiana. He distinguished himself as a trumpet and cornet player, a respected music teacher, and a teller of tall tales. After enjoying an early career playing in New Orleans, he toured the nation and the world with circus and minstrel shows. In 1931, Johnson lost his teeth and his trumpet during a fight. His music career revived in the late 1930s when he was discovered by the researchers for the book *Jazzmen*, and generous fellow artists and writers treated him to new teeth and a new horn. With a traditional jazz revival brewing, Johnson shone in a second act, from coast to coast. He recorded his first record for Jazz Man Records in 1942. (San Francisco Traditional Jazz Foundation, ARS.0030. Courtesy of the Stanford Archive of Recorded Sound, Stanford University Libraries.)

Here, a flyer from the Hot Jazz Society of San Francisco announces a jazz jam with Bunk Johnson and his "Hot Seven." Johnson was fond of claiming that he taught Louis Armstrong how to play the trumpet; like many stories in the music business, the truth is subject to interpretation. (San Francisco Traditional Jazz Foundation, ARS.0030. Courtesy of the Stanford Archive of Recorded Sound, Stanford University Libraries.)

Louis Armstrong and Bunk Johnson PETER TAMONY

Invites you to

Sunday Afternoon JAZZ SESSIONS

Featuring

BUNK JOHNSON

and his

"Hot Seven"

(Former Lu Watters Stars)

—— in the ——

CIO HJS CHAMBER JAZZ ROOM

150 Golden Gate Avenue

EVERY SUNDAY 2:15 P.M.

Commencing July 11, 1943

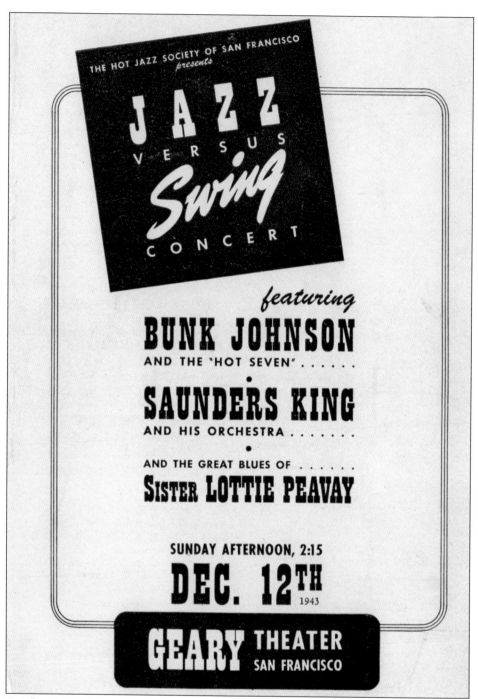

THE HOT JAZZ SOCIETY OF SAN FRANCISCO
presents

JAZZ VERSUS *Swing* CONCERT

featuring

BUNK JOHNSON
AND THE 'HOT SEVEN'

SAUNDERS KING
AND HIS ORCHESTRA

AND THE GREAT BLUES OF
SISTER **LOTTIE PEAVAY**

SUNDAY AFTERNOON, 2:15
DEC. 12TH 1943

GEARY THEATER SAN FRANCISCO

A 1942 flyer for Jazz Versus Swing features Bunk Johnson, Saunders King, and Sister Lottie Peavey, a popular blues and gospel singer. Johnson and Peavey recorded with the YBJB in 1944 for Good Time Jazz Records. This concert was presented by the Hot Jazz Society of San Francisco, another great promoter of jazz music. (San Francisco Traditional Jazz Foundation, ARS.0030. Courtesy of the Stanford Archive of Recorded Sound, Stanford University Libraries.)

Seen here is the program for Jazz Versus Swing, a musical face-off between Johnson's band and King's band. (Both, San Francisco Traditional Jazz Foundation, ARS.0030. Courtesy of the Stanford Archive of Recorded Sound, Stanford University Libraries.)

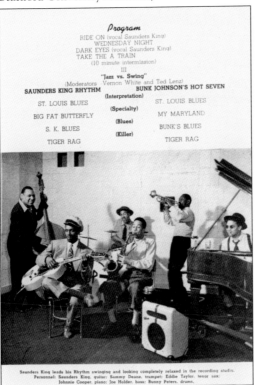

Program
"Jazz vs. Swing"

I

WILLIE "BUNK" JOHNSON
and the Hot Seven

(Vernon White Moderator)

DOWN BY THE RIVER (theme)
MILENBERG JOYS (vocal Bob Bozt)
SOUTH
CARELESS LOVE (vocal Clancy Hayes)
KID ORY'S CREOLE TROMBONE
SISTER KATE
TIN ROOF BLUES

SISTER LOTTIE PEAVAY
sings
"It's Nobody's Fault But Mine"
"When I Move To the Sky"

MUSKRAT RAMBLE
(10 minute intermission)

II

SAUNDERS KING RHYTHM
(Ted Lenz—Moderator)

S. K. GROOVE (theme)
JIVE AT ELEVEN FIVE
SUMMERTIME (vocal Saunders King)
VAGABOND LOVER

The joyful driving horn of Bunk Johnson fronts the Hot Seven posing for the phonographer. Personnel: Willie "Bunk" Johnson, trumpet; Ellis Horne, clarinet; Turk Murphy, trombone; Pat Patton, banjo; Squire Girsback, bass; Bill Dart, drums. (Bill Bardin, trombone and Lefty Benjamin, drums, are also "regulars" not in picture.)

Program

RIDE ON (vocal Saunders King)
WEDNESDAY NIGHT
DARK EYES (vocal Saunders King)
TAKE THE A TRAIN
(10 minute intermission)

III
"Jazz vs. Swing"
(Moderators Vernon White and Ted Lenz)

SAUNDERS KING RHYTHM		BUNK JOHNSON'S HOT SEVEN
ST. LOUIS BLUES	(Interpretation)	ST. LOUIS BLUES
BIG FAT BUTTERFLY	(Specialty)	MY MARYLAND
S. K. BLUES	(Blues)	BUNK'S BLUES
TIGER RAG	(Killer)	TIGER RAG

Saunders King leads his Rhythm swinging and looking completely relaxed in the recording studio. Personnel: Saunders King, guitar; Sammy Deane, trumpet; Eddie Taylor, tenor sax; Johnnie Cooper, piano; Joe Holder, bass; Bunny Peters, drums.

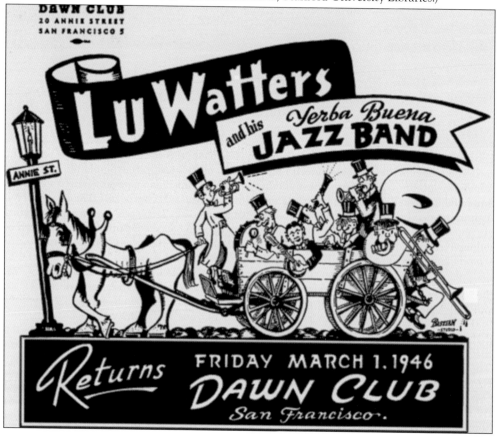

The Montgomery Street

Skylight

Friday, June 14, 1946

Blue Notes

New Label for Watters Discs

Lu Watters and The Yerba Buena Jazz Band have hit the jazz record market with eight sides of New Orleans style under their own label of West Coast Recordings. Tags are Canal Street Blues and Antigua Blues (WeC 101), Chattanooga Stomp and Creole Blues (WeC 102), Trombone Rag and Sunburst Rag (WeC 103) and Big Bear Stomp and Working Man Blues (WeC 104). Personnel is Watters (cornet), Bob Scobie (trumpet), Turk Murphy (trombone), Bob Helm (clarinet), Dick Lammi (tuba), Harry Mordecai (banpo), Bill Dart (drums) and Wally Rose (piano).

Listeners, of course, will pick their own favorites from the group. Personally, Working Man Blues had the most kicks for me. The band played together beautifully and with more relaxed feeling than shown on the other platters. Trombone Rag sounded a bit tight and strained to my ears. The other six should please Watters fans—and I am one. All eight sides show a tendency to subordinate the brass — even Turk's mighty tram—in comparison to their roles on the stand at the Dawn Club, Helm's clarinet comes through every time and the rhythm section backing is almost perfect.

Dig these discs and chalk one up for Lu and the boys.

This excerpt offers more praise for Lu and the boys for a recording made shortly after their return from the war and recommencement of their gig at the Dawn Club: "The band played together beautifully and with more relaxed feeling than shown on the other platters." (San Francisco Traditional Jazz Foundation, ARS.0030. Courtesy of the Stanford Archive of Recorded Sound, Stanford University Libraries.)

This is the announcement for the return of Lu Watters and the YBJB to the Dawn Club after the war. (San Francisco Traditional Jazz Foundation, ARS.0030. Courtesy of the Stanford Archive of Recorded Sound, Stanford University Libraries.)

**MONDAY
AUGUST 25th
9:00 P. M.
DAWN CLUB**
20 Annie Place

Nº 1323

Hot Music Society of San Francisco
— presents —
LU WATTERS
and the YERBA BUENA JAZZ BAND
Lu Watters, Bob Scobey, Turk Murphy, Ellis Horne,
Clancy Hayes, Augie Blanchard, Wally Rose,
Bill Dart

Tickets on Sale { Rowland Music Co., 38 Mason St.
Melander's, 172 Eddy Street
The White House Record Shop

Price of this Ticket: From a Member: 45c, Tax 5c—50c
Door at Session: 68c, Tax 7c—75c
55

This ticket is from a performance of the Lu Watters and the YBJB at the Dawn Club. (San Francisco Traditional Jazz Foundation, ARS.0030. Courtesy of the Stanford Archive of Recorded Sound, Stanford University Libraries.)

This menu cover from Hanbone Kelly's announces the appearance of the Lu Watters Jazz Band at the venue. Watters moved Hambone Kelly's across the bay to El Cerrito after he and Turk Murphy parted ways in the late 1940s. Hambone Kelly's often served a thousand customers over a weekend. (San Francisco Traditional Jazz Foundation, ARS.0030. Courtesy of the Stanford Archive of Recorded Sound, Stanford University Libraries.)

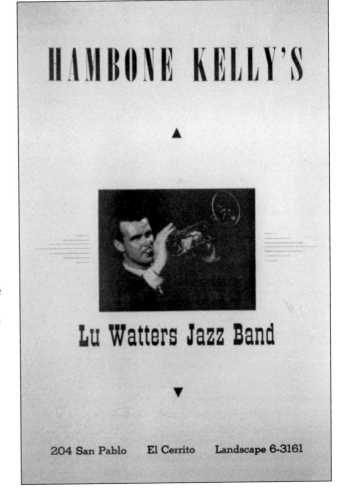

HAMBONE KELLY'S

Lu Watters Jazz Band

204 San Pablo El Cerrito Landscape 6-3161

DINNERS

5:00 to 8:00 P.M. — A LA CARTE TILL 1:00 A.M.
SPECIAL $1.25 DINNER 5:00 to 7:00 P.M.
TAKE HOME ORDERS 5:00 to 12:00 P.M.
OLD TIME MOVIES 6:00 to 8:30 P.M.
LU WATTERS JAZZ BAND 9:00 P.M. (Except Mondays)

MENU

★

	(A LA CARTE)	(WITH DINNER)
Daily Special (5:00 to 7:00 P.M.)	1.00	1.25
Barbecued Spareribs, Specialty of the House	1.65	1.90
Fried Chicken	1.25	1.50
Beef and Spaghetti, Italian Style	1.25	1.50
Homemade Raviolis, with Mushroom Sauce	1.25	1.50
Top Sirloin Steak	1.75	2.00
T-Bone Steak	1.50	1.75
Hamburger Steak	1.00	1.25
Hamburger on French Bread	.75	
Spareribs "To Take Home"	1.50	
Tossed Salad	.35	

JAZZ CONCERT EVERY SUNDAY 2:00 to 6:00 P.M.

Featuring Outstanding Guest Bands

BAR AND RESTAURANT OPEN AT 1:00 P.M.

	Large	Small
Ambassador Grignolino Rose (soft and delicate)	2.00	
Ambassador Cabernet (medium-bodied)	2.00	1.00
Ambassador Burgundy (superbe bouquet)	2.00	1.00
Ambassador Zinfandel (dry and fruity)	2.00	1.00
Ambassador Claret (very light and dry)	2.00	1.00

White

Ambassador Chablis (flinty)	2.00	1.00
Ambassador Dry Sauterne (rich and full-bodied)	2.00	1.00
Ambassador Semillon	2.00	
Ambassador Haut Sauterne (medium sweet)	2.00	1.00
Ambassador Pinot Chardonnay (very dry and delicate)	2.25	
Ambassador Sauvignon Vert (very dry with med. bouquet)	2.25	

WENTE BROS. WINES

Mourestel		1.00
Grey Riesling		1.00
Chablis		1.00

CHRISTIAN BROS. WINES

Burgundy	2.00	1.00
Claret	2.00	1.00
Sauterne	2.00	1.00

ITALIAN SWISS COLONY WINES

Burgundy	1.50	.75
Tipo		1.00
Sauterne	1.50	.75

CHAMPAGNE

Golden State (extra dry)	5.00	2.50
Greystone	4.00	2.00
Roma	3.50	1.75
Italian Swiss Colony	4.00	2.00
Mumm's	10.00	

SPARKLING BURGUNDY

Asti Rouge	5.00	2.50
Greystone	4.00	2.00
Roma	3.50	1.75
Italian Swiss Colony	4.00	2.00

Cocktails and Mixed Drinks

BOURBON

Bottled in Bond	.65	
	Straights	.60

SCOTCH

White Horse	.65	
Black & White	.65	Johnnie Walker, Red Label .65
Ballantine's	.65	Haig & Haig, Pinch Bottle .65
		Cutty Sark .65

BRANDIES

A. R. Morrow Bonded	.60	Christian Bros. .60
Aristocrat	.50	Imported Cognacs .65
Coronet	.50	

WHISKEY

Old Overholt Rye	.65	Seagrams V.O. .65
Bushmills Irish Whiskey	.65	McNaughtons Canadian .65

COCKTAILS

Martini	.60	Bacardi .65
Manhattan	.60	Daiquiri .65
Old Fashion	.60	Whiskey Sour .60
Gibson	.60	Dubonnet .60

MIXED DRINKS

Hot Drinks	.65	Gin Ricky .50
Rum Highball	.50	Dubonnet Sherry .50
Tom Collins	.60	Silver or Golden Fizz .75
Gin Fizz	.60	

CORDIALS

King Alphonse	.60	Kummel .60
Cherry Liqueur	.60	Creme de Menthe .60
Anisette	.60	Creme de Cocoa .60
Benedictine and Brandy	.60	Kahlua .60

BEER

Eastern Beer before 9:00 P.M.	.35	After 9:00 P.M. .50

This menu from Hambone Kelly's notes Sunday-afternoon jazz concerts and nightly performances by Lu Watters's Jazz Band (except Mondays.) Note that only one item, Eastern Beer, increased in price by 25 percent after 9:00 p.m. (San Francisco Traditional Jazz Foundation, ARS.0030. Courtesy of the Stanford Archive of Recorded Sound, Stanford University Libraries.)

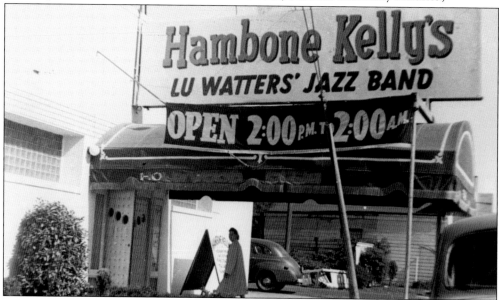

The facade of Hambone Kelly's, with its ample sign, welcomed guests from early afternoon until early morning. The cavernous club boasted a bar 100 feet long and a dance floor that accommodated up to 400 revelers. Many of the band members and their families lived on-site. (Photograph by Harry Mordecai; San Francisco Traditional Jazz Foundation, ARS.0030. Courtesy of the Stanford Archive of Recorded Sound, Stanford University Libraries.)

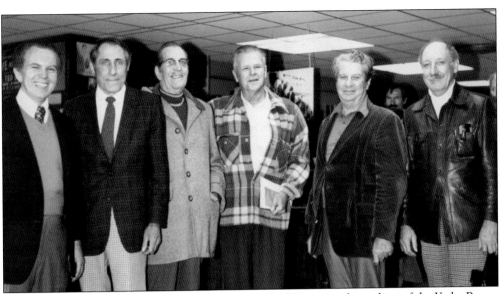

This image from January 1975 captures a reunion of Lu Watters and members of the Yerba Buena Jazz Band on the occasion of the exhibit of San Francisco Traditional Jazz Foundation's memorabilia at the Sutro Library, which was to form the foundation of the San Francisco Jazz museum. From left to right are Wally Rose, Harry Mordecai, Pat Patton, Lu Watters, Turk Murphy, and Bob Helm. (Photograph by Edward Lawless; San Francisco Traditional Jazz Foundation, ARS.0030. Courtesy of the Stanford Archive of Recorded Sound, Stanford University Libraries.)

BAYSIDE JAZZ SOCIETY *Presents*

THE FIRST LOCAL APPEARANCE OF THE BAY AREA'S

Sensational New Jazz Group

BOB MIELKE'S BARBARY COAST STOMPERS

NORMAN KLEHM, Trumpet BOB MIELKE, Trombone DICK LAMMI, Bass
BILL NAPIER, Clarinet JERRY STANTON, Piano BILL DART, Drums

Come One · **DANCING** · *Come All*

JENNY LIND HALL

2231 Telegraph Avenue · Oakland, California

SUNDAY AFTERNOON, JULY 1st, 1951 · 2 to 6 p.m.

General Admission $1.00 (FEDERAL TAX INCLUDED) B. J. S. Members 75 cents

Bob Mielke's career spanned just about 60 years, beginning in the 1930s and ending just recently. He was a fixture in San Francisco's traditional jazz universe and played with everyone from Sidney Bechet to Wingey Manone and in venues from the Jenny Lind to the Oakland Athletics' ballpark. Turk Murphy relied on Mielke to fill in for him on trombone at Earthquake McGoon's so that the house would remain reliably packed and appropriately entertained when Murphy hit the tour circuit. Mielke could deftly slide his trombone Kid Ory tailgate style, in a Harlem Swing, and in a range of styles in between. (San Francisco Traditional Jazz Foundation, ARS.0030. Courtesy of the Stanford Archive of Recorded Sound, Stanford University Libraries.)

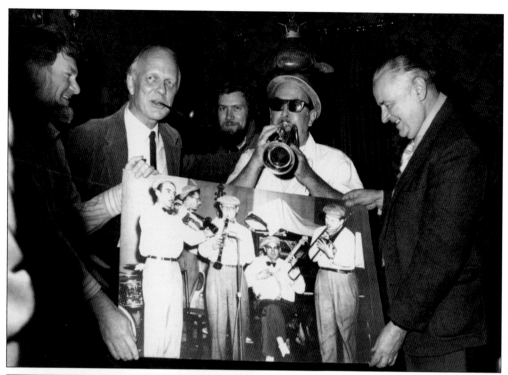

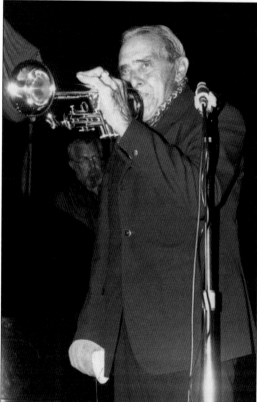

Bob Mielke (left) and jazz club director Mike Gerba (right) present a 1950s photograph of Mielke's Bearcats. P.T. Stanton hams it up with his horn, while Ray Skjelbred (pianist and bandleader who played with the Bearcats) and a fan look on. Many different musicians rotated into and out of the Bearcats; the configuration in the photograph being presented is, from left to right, Stanton, Pete Allen, Bunky Coleman, Dick Oxtot, and Mielke. (Photograph by Edward Lawless; San Francisco Traditional Jazz Foundation, ARS.0030. Courtesy of the Stanford Archive of Recorded Sound, Stanford University Libraries.)

Joseph Matthews "Wingey" Manone, a trumpet player, composer, and bandleader, hailed from New Orleans. He was nicknamed "Wingey" because of the loss of his right arm in a streetcar accident at the age of 10. He performed flawlessly with a prosthetic. (Photograph by Edward Lawless; San Francisco Traditional Jazz Foundation, ARS.0030. Courtesy of the Stanford Archive of Recorded Sound, Stanford University Libraries.)

Stan Ward (left) and Tom Marks are pictured at Club Hangover with a "Tilt" sign devised by Ward; he would raise the sign each time Manone made a mistake during a performance. (San Francisco Traditional Jazz Foundation, ARS.0030. Courtesy of the Stanford Archive of Recorded Sound, Stanford University Libraries.)

Here, Bob Scobey's Frisco Band is performing in 1951. Trumpet master Robert Alexander Scobey Jr. (1916–1963) left the YBJB to start his own group, which he led until launching a solo career in 1959. (San Francisco Traditional Jazz Foundation, ARS.0030. Courtesy of the Stanford Archive of Recorded Sound, Stanford University Libraries.)

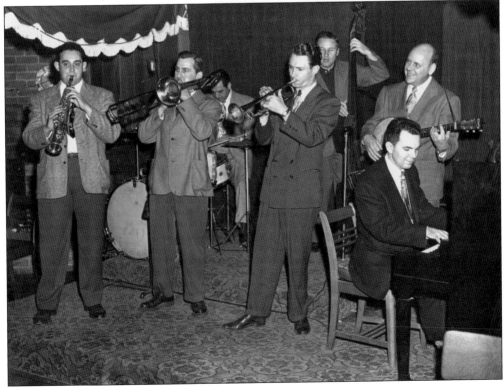

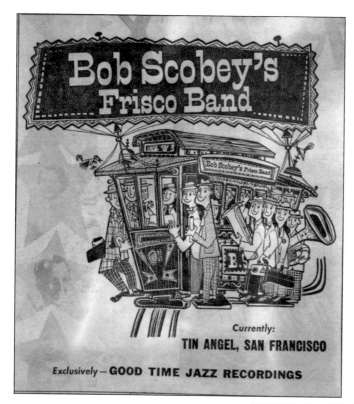

Currently:
TIN ANGEL, SAN FRANCISCO

Exclusively — **GOOD TIME JAZZ RECORDINGS**

This 1954 advertisement is for Bob Scobey's Frisco Band's performance at the Tin Angel. Good Time Jazz Recordings signed many of the local jazz bands and performers and, with other labels, helped put a floor under many artists by promoting their music with radio stations, clubs, and jazz aficionados. (San Francisco Traditional Jazz Foundation, ARS.0030. Courtesy of the Stanford Archive of Recorded Sound, Stanford University Libraries.)

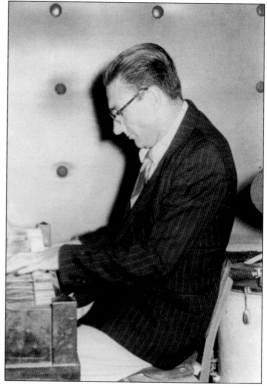

Burt Bales (1916–1989) plays the piano at Victor and Roxie's in Oakland in 1952. Bales also recorded on the Good Time Jazz label. (San Francisco Traditional Jazz Foundation, ARS.0030. Courtesy of the Stanford Archive of Recorded Sound, Stanford University Libraries.)

BURT BALES BENEFIT

This ticket admits bearer to any or all
of the following clubs:

The Kewpie Doll, Broadway and Columbus

Pier 23, The Embarcadero

On the Levee, Opposite Pier 23

The Cellar, 576 Green street

On the night of March 22, 1960 **8:30 'til**

Fellow musicians rallied together at four different venues to raise money for Bales's expenses after he was struck and injured by a motorist while crossing the street. (San Francisco Traditional Jazz Foundation, ARS.0030. Courtesy of the Stanford Archive of Recorded Sound, Stanford University Libraries.)

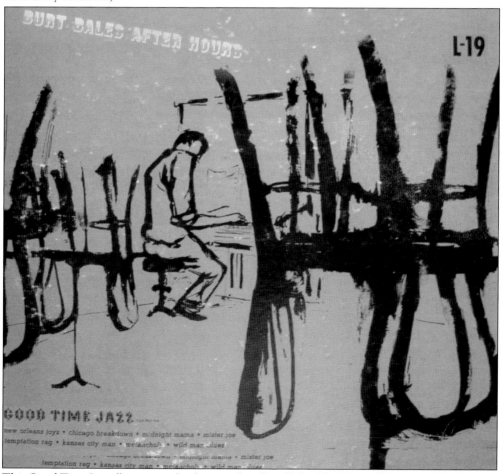

This Good Time Jazz album cover for the recording *Burt Bales After Hours* illustrates Bales's affinity for Jelly Roll Morton; five of the eight cuts are Morton's compositions. (Author's collection.)

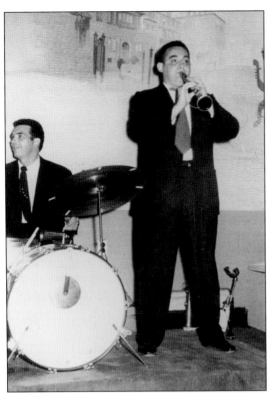

George Probert plays the clarinet, and Bill Young, the drums, at Victor and Roxie's (Oakland) in 1953. Probert also played in Kid Ory's band at Club Hangover. George Probert's Jazz Band performed locally with Bob Scobey and with Kid Ory's Creole Jazz Band in the early 1950s. A Los Angeles native, Probert went on to play in a band populated with animators from the Disney studios in the later 1950s and 1960s. He toured nationally and internationally for the next several decades, and he has recorded extensively on the Jazz Crusade and Jazzology Records labels. (San Francisco Traditional Jazz Foundation, ARS.0030. Courtesy of the Stanford Archive of Recorded Sound, Stanford University Libraries.)

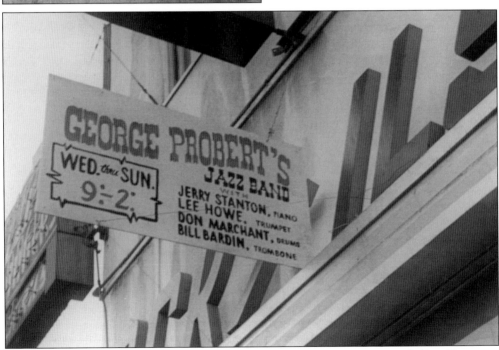

A sign announces the hours for appearances by George Probert's Jazz Band. (San Francisco Traditional Jazz Foundation, ARS.0030. Courtesy of the Stanford Archive of Recorded Sound, Stanford University Libraries.)

Four

THE TURK MURPHY ERA

After Lu Watters retired, Turk Murphy hit the road with his band intact. Eschewing drums, Murphy relied on the tuba to keep the beat. This iteration of the Turk Murphy Band opened in the basement of the Italian Village at Columbus Avenue and Lombard Street in North Beach in January 1952 and held court there for two more years. The band also gigged at the Tin Angel after Peggy Tolk-Watkins opened at 981 Embarcadero in 1953. Kid Ory owned the club from 1958 until 1961 and named it On the Levee.

Murphy and partner Pete Clute (piano) opened Earthquake McGoon's, first at the Evans Hotel at 99 Broadway in September 1957, then at 630 Clay Street in early 1962, and finally on the Embarcadero, where it would stay until its closing in 1984. Named for the character in Al Capp's comic strip *Li'l Abner* (with the cartoonist's blessing), Earthquake McGoon's anchored San Francisco's traditional jazz scene for three decades.

Like Watters, Murphy learned to play the horn as a child, having come from a musical family that included the talent of his grandfather, a fiddler for the prospectors during the Gold Rush, and his father, who played both cornet and drums in various bands. Though he learned first to play the cornet his father gave to him at age 11, he fast settled on trombone. He started his musical career in his high school band and then lasted a year at Stanford before the call of the road beckoned. Playing in a jazz dance must have been Murphy's fate—he never returned to college and spent the next half century as a bandleader, composer, recording artist, and jazz historian.

Melvin Edward Alton "Turk" Murphy (1915–1986) made it his mission to put San Francisco on every jazz lover's map. (His nickname comes from his high school football days when the hulking Murphy was called "Terrible Turk.") Murphy became the "dean" of the San Francisco traditional jazz scene, in turns supporting and terrifying those musicians who aspired to the stage. Despite a stammer that dogged him most of his life, a blowing style that frequently resulted in bloody lips, and a penchant for edgy (some victims called it "sadistic") humor, he inspired decades of traditional jazz lovers through his performances and recordings. He moved beyond the Watters

style of the original Yerba Buena Jazz Band. Influenced in part by his veneration of the hot jazz icon Kid Ory and appreciation of Jack Teagarden's lyricism and technical rigor, Turk developed his own sound.

His dedication to the music he revered extended beyond simply forming and leading a band. A serious, disciplined composer, Murphy penned countless arrangements, both interpretations of original traditional jazz pieces and his own unique scores. He would start with research: listening to a recording, studying the sheet music, interviewing the composer if possible. Then, he would transpose the sound to notes on a page, assemble the band, and start playing from this skeleton suggestion, playing until the notes were memorized. Only then would the sheet music be set aside so that the musicians could play the notes they felt. They would not change the notes, but rather interpret the pace, flirt with the chorus, and feel the sway and swagger of the music. The only time the band would take no liberties with the original was on a traditional solo, like Louis Armstrong's cornet on "Dippermouth Blues"; otherwise, the band was free to coalesce around the notes, respecting the original yet interpreting it in its own image.

By the 1970s, the band fancied itself "the best jazz band ever," but Murphy did not tolerate grandstanding. "Perseverance was the main thing for Turk's success. 'Persevere,' Turk said, 'and you finally get there,'" remembered banjo player Carl Lunsford (BANC MSS 2014/155, "Turk Murphy, Earthquake McGoon's and the New Orleans Revival"/Carl Landsford interview transcript, the Bancroft Library, University of California, Berkeley).

When Murphy died in 1987, his life and his timeless contributions to the music world and to the broader community were celebrated during services at the storied Grace Cathedral on Nob Hill. His longtime friend *San Francisco Examiner* music critic Phil Elwood delivered the eulogy.

Turk Murphy blows on a trombone. (Photograph by Edward Lawless, San Francisco Traditional Jazz Foundation, ARS.0030. Courtesy of the Stanford Archive of Recorded Sound, Stanford University Libraries.)

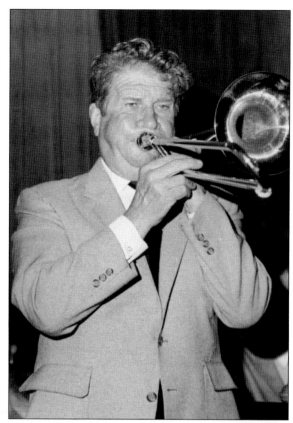

Streetlights illuminate Turk Murphy's nightclub, Earthquake McGoon's, a local jazz hot spot from 1960 until it closed in 1984. It moved from its original 630 Clay Street venue to the waterfront in the 1970s. The club had featured polka music before Murphy occupied the space; its layout and acoustics showcased live music. Turk was much loved and respected and was known for fostering the careers of young musicians who were serious about their craft. His "blustery" sound was his interpretation of original, traditional jazz. (Photograph by Edward Lawless; San Francisco Traditional Jazz Foundation, ARS.0030. Courtesy of the Stanford Archive of Recorded Sound, Stanford University Libraries.)

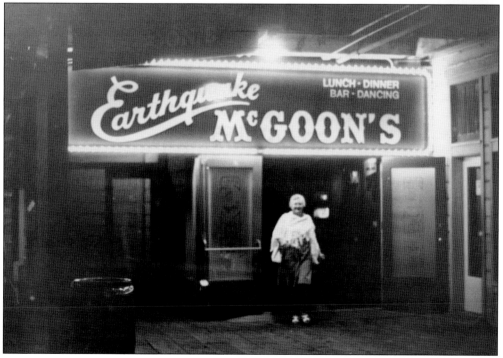

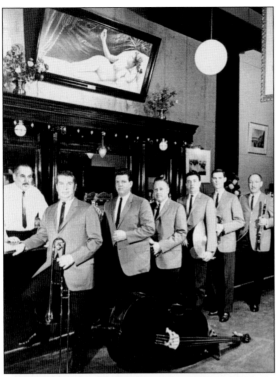

Murphy's band stands posed next to the bar, which was graced from above by an iconic painting of a nude reclining. (San Francisco Traditional Jazz Foundation, ARS.0030. Courtesy of the Stanford Archive of Recorded Sound, Stanford University Libraries.)

The band's rhythms call dancers to the floor at Earthquake McGoon's. (San Francisco Traditional Jazz Foundation, ARS.0030. Courtesy of the Stanford Archive of Recorded Sound, Stanford University Libraries.)

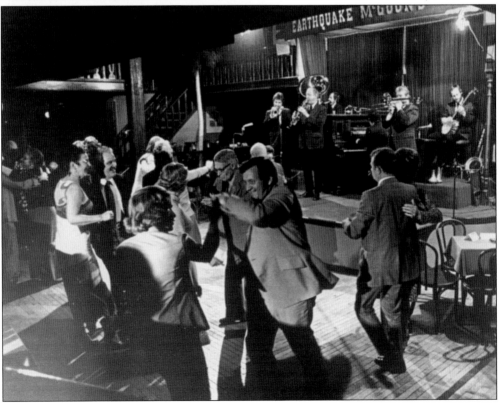

The glass-enclosed notice board in front of Earthquake McGoon's held the dinner menu, publicity photographs, and notices. The headline for the newspaper article at right reads, "Woody Allen Revealed as Mouldy Fig." *Moldy fig* is a term used by bebop fans to describe traditional jazz devotees. Allen, a fan of Murphy's trumpet sound, played his own horn here after Murphy cajoled him countless times to take the stage. (San Francisco Traditional Jazz Foundation, ARS.0030. Courtesy of the Stanford Archive of Recorded Sound, Stanford University Libraries.)

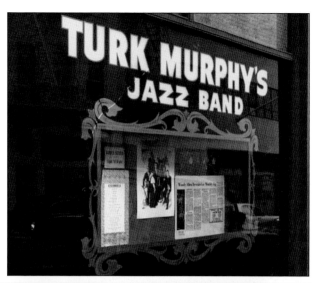

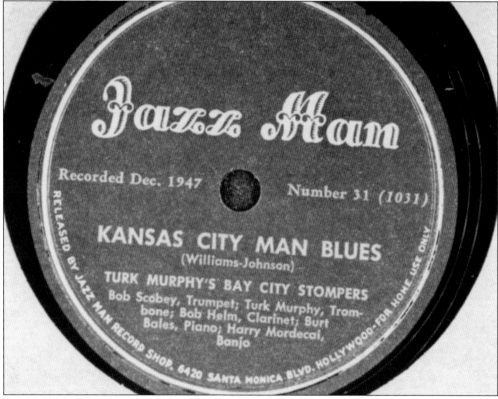

This is the label for Turk Murphy's Bay City Stompers' recording of "Kansas City Man Blues," recorded on Jazz Man in 1947. Most of the original YBJB band members appear on the recording. Los Angeles's Jazz Man Records grew from an eponymous Sunset Strip record store owned by Dave Stuart. Jazz Man also recorded Lu Watters, Kid Ory, and Bunk Johnson. The Turk Murphy Jazz Band recorded copiously over four decades on the Columbia, Good Time Jazz, and West Coast labels. (San Francisco Traditional Jazz Foundation, ARS.0030. Courtesy of the Stanford Archive of Recorded Sound, Stanford University Libraries.)

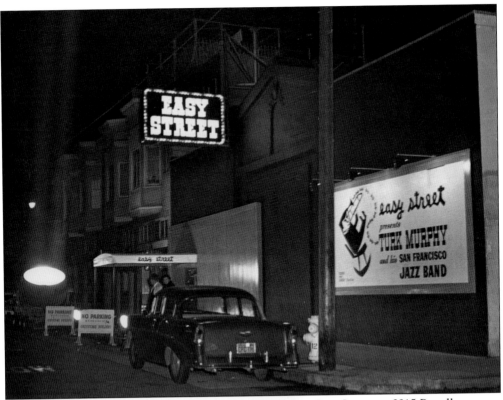

Easy Street, at 2215 Powell Street, was another of Murphy's nightclubs. (San Francisco Traditional Jazz Foundation, ARS.0030. Courtesy of the Stanford Archive of Recorded Sound, Stanford University Libraries.)

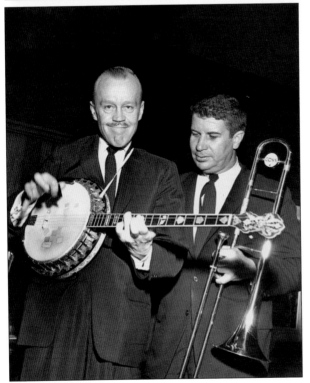

Dick Lammi (left) and Turk Murphy pose with their instruments at Easy Street. (San Francisco Traditional Jazz Foundation, ARS.0030. Courtesy of the Stanford Archive of Recorded Sound, Stanford University Libraries.)

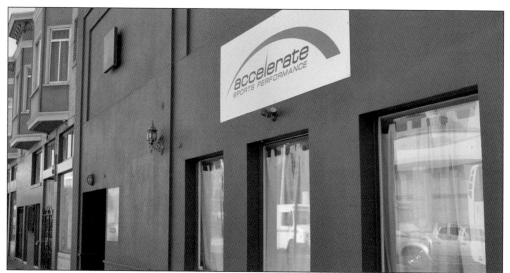

The former Easy Street location now features another kind of action—offering athletes professional guidance to attain peak performance. (Courtesy of Marianna Ford.)

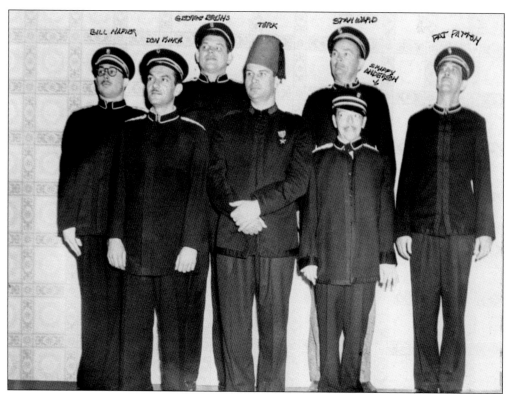

A Turk Murphy assemblage, appearing as "Turk Murphy and the Circus Jazz Band," poses at the Aragon Ballroom in April 1950. Pictured are, from left to right, Bill Napier, clarinet; Don Kinch, trumpet; George Bruns, trombone; Turk Murphy, trombone; Stan Ward, drums; Skippy Anderson, piano; and Pat Patton, banjo. (San Francisco Traditional Jazz Foundation, ARS.0030. Courtesy of the Stanford Archive of Recorded Sound, Stanford University Libraries.)

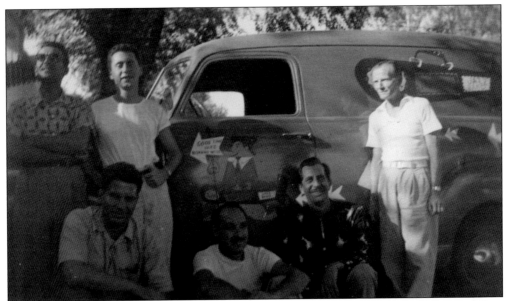

The Turk Murphy Jazz Band and its bus are shown here on August 8, 1951. Pictured, from left to right, are Don Kinch, Turk Murphy (crouching), unidentified (maybe Jerry Stanton), Bob Helm, Pat Patton, and Johnny Brent. (San Francisco Traditional Jazz Foundation, ARS.0030. Courtesy of the Stanford Archive of Recorded Sound, Stanford University Libraries.)

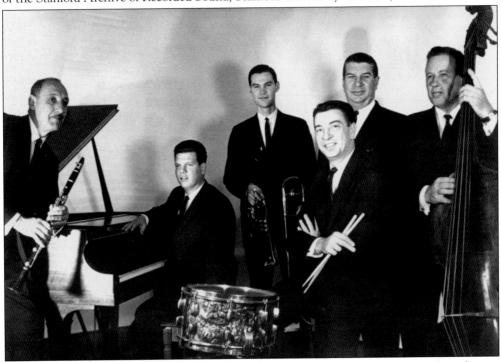

The Turk Murphy band is photographed here in the early 1960s sporting a more formal pose; members are, from left to right, Bob Helm, Pete Clute, Bob Neighbor, Thad Vanden, Turk Murphy, and Squire Girsbach. (San Francisco Traditional Jazz Foundation, ARS.0030. Courtesy of the Stanford Archive of Recorded Sound, Stanford University Libraries.)

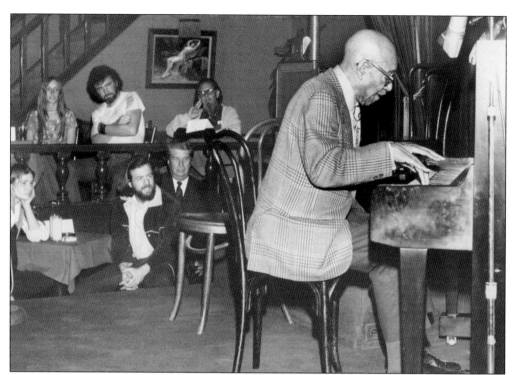

James Hubert "Eubie" Blake performs at Earthquake McGoon's, with Turk Murphy joining the appreciative audience. Blake (1883–1983) was lionized for his jaunty ragtime piano. He began performing at the age of 15 in a Baltimore brothel and continued almost without interruption until his death. His San Francisco performances included a gig at the venerable Great American Music Hall, a venue that remains a San Francisco favorite. (Both, photograph by Edward Lawless; San Francisco Traditional Jazz Foundation, ARS.0030. Courtesy of the Stanford Archive of Recorded Sound, Stanford University Libraries.)

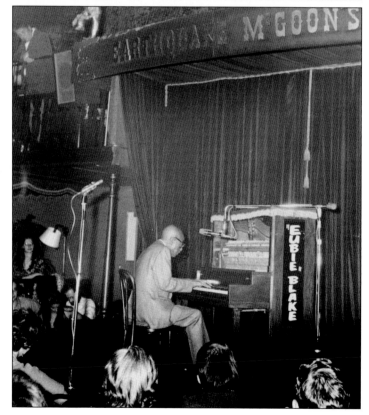

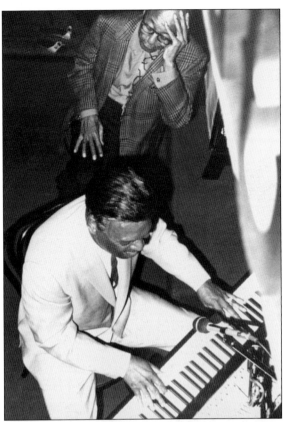

Eubie Blake looks on as Earl "Fatha" Hines takes his turn at the piano on March 28, 1971. (Photograph by Edward Lawless; San Francisco Traditional Jazz Foundation, ARS.0030. Courtesy of the Stanford Archive of Recorded Sound, Stanford University Libraries.)

Turk Murphy sasses it up with local jazz diva Pat Yankee. (Photograph by Edward Lawless; San Francisco Traditional Jazz Foundation, ARS.0030. Courtesy of the Stanford Archive of Recorded Sound, Stanford University Libraries.)

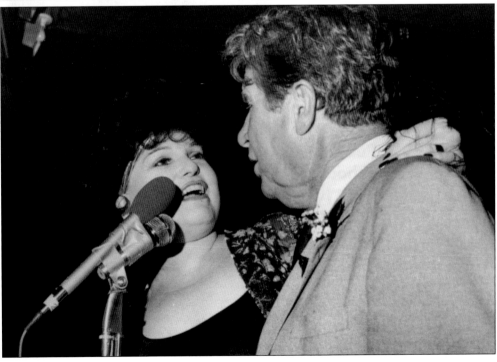

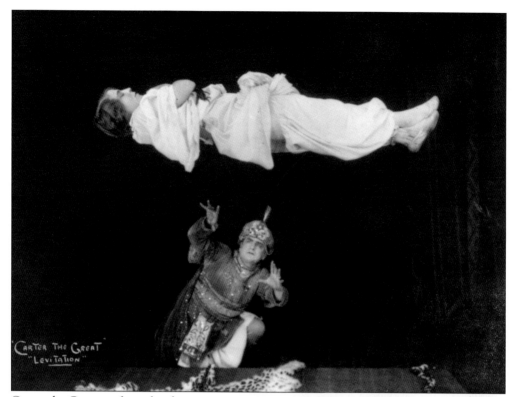

Carter the Great performs his famous levitation trick. Carter was a renowned San Francisco magician in the 1930s. The archive of his life, "twenty five tons of ponderous impedimenta" including his writing, photographs, props, and secrets, wound up in the Magic Cellar (the basement of Earthquake Goon's) as a museum after Turk bought the entire collection, sight unseen, from Carter's family after his death. Turk and Carter had had side-by-side storage lockers, and Turk was a brave and curious man. (San Francisco Traditional Jazz Foundation, ARS.0030. Courtesy of the Stanford Archive of Recorded Sound, Stanford University Libraries.)

Here is the notice for the 35th annual wake for magician Carter the Mysterious held at the Magic Cellar at Earthquake McGoon's. (San Francisco Traditional Jazz Foundation, ARS.0030. Courtesy of the Stanford Archive of Recorded Sound, Stanford University Libraries.)

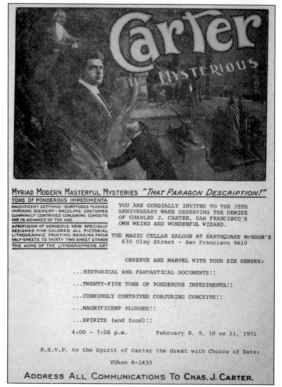

TURK MURPHY

JAZZ BAND

NOW AT

THE TIN ANGEL

987 THE EMBARCADERO
SAN FRANCISCO ★ SU 1-2364

Not Valid Friday or Saturday

THIS PASS
ADMITS ONE
½ PRICE

Here is a ticket for a performance by the Turk Murphy Jazz Band at the Tin Angel on the Embarcadero. (San Francisco Traditional Jazz Foundation, ARS.0030. Courtesy of the Stanford Archive of Recorded Sound, Stanford University Libraries.)

"I just happened to bring my horn"

The back of Murphy's business card sports this caricature of a barefoot Murphy and his well-worn horn. (San Francisco Traditional Jazz Foundation, ARS.0030. Courtesy of the Stanford Archive of Recorded Sound, Stanford University Libraries.)

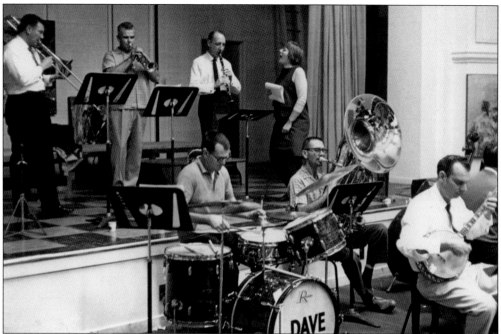

In 1963, Lu Watters briefly abandoned retirement, Barbara Dane took a breather from running her Sugar Hill club, and the pair recorded an antinuclear protest album with a group of like-minded musician friends. Their contribution formed part of a larger effort to prevent the California Public Utilities Commission (CPUC) from building a nuclear power plant in a quiet hamlet north of San Francisco called Bodega Bay. Whether or not the CPUC heeded the protestors, California's first nuclear plant site migrated farther north to Humboldt Bay near Eureka. The musicians rehearsing "Blues Over Bodega" as the Lu Watters Band include Bob Mielke, trombone; Watters, trumpet; Bob Helm, clarinet; Dane, vocals; Dave Black, drums; Bob Short, tuba; Monty Ballou, banjo; and Wally Rose, piano. (Courtesy of William Carter.)

JAZZ CONCERT
BODEGA BAY BENEFIT

Sunday, July 28, 1963 — 4 to Midnight

EARTHQUAKE McGOON'S — 630 Clay St, San Francisco

- Turk Murphy's Jazz Band
- Barbara Dane
- Goodtime Washboard
- Lu Watters, Guest Artist
- Malvina Reynolds
- The Firing Squad

ADMIT ONE DONATION: $5.00

50c children under 12 $2.50 for Voting Members

All proceeds to Northern California Association to Preserve Bodega Head and Harbor

No. 0013

Seen here is a ticket for the Bodega Bay Benefit held at Earthquake McGoon's with guest artist Lu Watters. (San Francisco Traditional Jazz Foundation, ARS.0030. Courtesy of the Stanford Archive of Recorded Sound, Stanford University Libraries.)

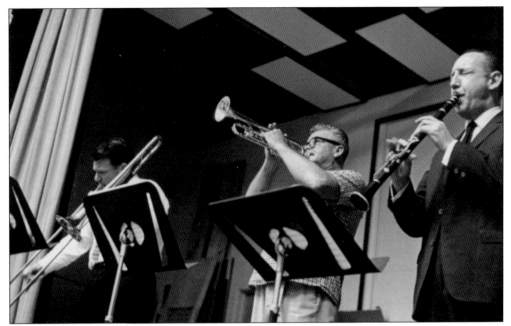

Bob Mielke (left), Lu Watters (center), and Bob Helm demonstrate their passion for their music while working together again, rehearsing for the Bodega Bay Benefit to support the antinuclear movement. (Courtesy of William Carter.)

Pianist Wally Rose enjoyed a successful classical music career in addition to his storied jazz success. (Courtesy of William Carter.)

Watters (right) and Helm (below) practice their respective horns during the rehearsal sessions, which were held at the old rehearsal hall for the Musicians Union Local 6 at 230 Jones Street. When the hall, designed by Sylvian Schnaittacher, was constructed in 1924, it stood at the epicenter of San Francisco's downtown, proximate to all of the theaters, hotels, restaurants, and dance halls that would typically employ musicians. (Both, courtesy of William Carter.)

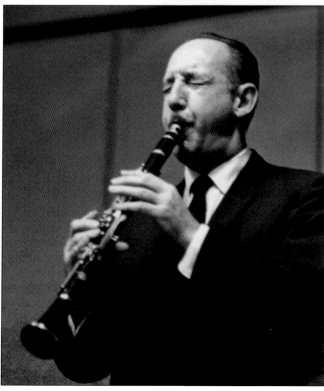

Turk Murphy (left) and Phil Elwood pose for a picture in the early days of their enduring friendship. (San Francisco Traditional Jazz Foundation, ARS.0030. Courtesy of the Stanford Archive of Recorded Sound, Stanford University Libraries.)

A street named for Murphy in North Beach sits across Vallejo Street from the former home of Keystone Korner. (Courtesy of Harley Bruce Photography.)

Five

DAVE BRUBECK AND THE BIRTH OF WEST COAST COOL

Polyrhythms and polytonality are, along with counterpoint, elements that are expected in modern classical music, but local jazz pioneer Dave Brubeck brought them to jazz music and to San Francisco in the 1940s. Brubeck understood decades before anyone else that jazz's natural progression would ultimately encompass the music of the world, from African and South American rhythmic beats (that gave birth to the blues) to Asian minor scales. Perusing a current program listing for San Francisco's newest musical crown jewel, the SFJAZZ Center, will reveal just how prescient Brubeck was: Chucho Valdes and the Afro-Cuban Messengers, Danilo Perez, and Miguel Zenon all headline along with mainstream jazz musicians like Wynton Marsalis and Marcus Shelby.

Brubeck was raised on a cattle ranch, but his mother's love of classical music, especially Chopin, infected him early. He studied at Mills College in Oakland under Darius Milhaud, a Jewish composer who fled France in 1939 as the Nazi threat crystallized. Milhaud had gained prominence in his homeland as a prolific classical pianist and was recruited by Jean Cocteau to join a composer's group called "Les Six" before traveling to the United States and discovering jazz in 1922. On the Brubeck Institute's website, Brubeck claims that his goal as a musician was to be a person who "opened doors." Indeed, his unique and decidedly untested approach to jazz made him both controversial and iconic among jazz musicians, historians, and aficionados.

In his book *West Coast Jazz*, music historian Ted Gioia credits Brubeck's move to San Francisco and his recordings on his own Fantasy Label with launching the new sound of modern jazz. One of the doors Brubeck opened wide admitted local vibes (vibraphone) player Cal Tjader, who played with Brubeck's first trio from 1949 to 1950. Tjader, a graduate of San Francisco State, went on to play with the George Shearing Quintet and later teamed with Mongo Santamaria, Willie Bobo, Luis Gasca, Paul Horn, and Clare Fisher. Tjader injected a Latin rhythm into contemporary jazz and won a Grammy in 1981 for Best Latin Recording for *La Onda Va Bien*. Tjader recommended Oakland native and fellow San Francisco State student Ron Crotty to round out the trio on bass. (Today, octogenarian Crotty continues to perform regularly on his Tyrolean bass.) Local DJ Jimmy

Lyons caught the act during its regular gig at the Burma Lounge in Oakland, appreciated the unique sound, and featured the trio on weekly on his radio show. A decade later, Lyons would sign the group, by then a quartet, to headline at his new venture, the Monterey Jazz Festival.

Paul Desmond (né Breitenfeld) is perhaps best known for his work with the original 1951 Brubeck Quartet and his authorship of the first million-selling jazz single, the iconic "Take Five," in 1959. Born in San Francisco in 1924, the famously introverted Desmond played his lyrical (some said, "too pretty") alto sax with the quartet until it disbanded in 1967. Famed jazz journalist Stanley Crouch said of Brubeck, "Dave Brubeck doesn't really fit in the light version of West Coast Jazz . . . you had like the cool, fluid kind of playing that you got with Paul Desmond and then you had a much more aggressive kind of powerhouse approach from Brubeck. So you got that big contrast between the fluid way Paul Desmond played and the way Brubeck played. And I think that that was a lot of the appeal of the band." Desmond made his last stage appearance with Brubeck in New York, just before his death in 1977.

Many other talents shared the stage with various iterations of Brubeck's Quartet/Octet/Quintet, including drummer Gerry Mulligan and Brubeck's sons Darius (on keyboards), Chris (on bass and trombone), and Dan (on drums). Though the 1960s rock hysteria rolled through San Francisco and shuttered many of its jazz-centric clubs, Brubeck continued to experiment with his compositions and remained a venerated musical headliner until his death in 2012.

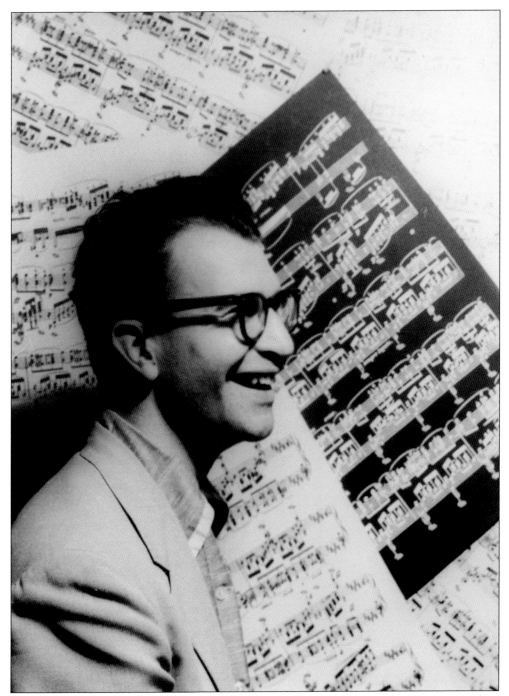

Dave Brubeck (1920–2012) contributed mightily to the jazz music canon, composing more than 500 pieces during his 60-year career. Touring college campuses with his quartet in the 1950s and 1960s, he exposed young people to his brand of jazz music. This musical diplomacy continued throughout his life, earning him countless fans at home and abroad, as well as scores of medals and awards. He was named a jazz master by the National Endowment for the Arts in 2000. (Courtesy of Library of Congress.)

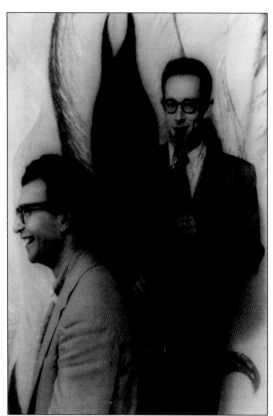

Brubeck paired with Desmond originally in 1951. The duo squared off the quartet with various bassists and drummers until 1958, when Brubeck formed the "classic" quartet. They enjoyed a long tenure as the house band for the Black Hawk, where they recorded several albums, both as a duo and as a quartet. (Courtesy of Library of Congress.)

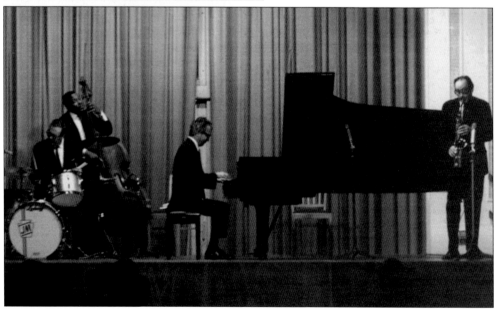

The Brubeck Quartet is pictured in 1967 with Joe Morello on drums, Eugene Wright on bass, and Paul Desmond on alto saxophone. Brubeck assembled this group in 1958, and it remained intact until the end of 1967. The classic quartet recorded and released the platinum album *Time Out*, on which the famed "Take Five" and "Blue Rondo à la Turk" appear. (Courtesy of Wikimedia Commons.)

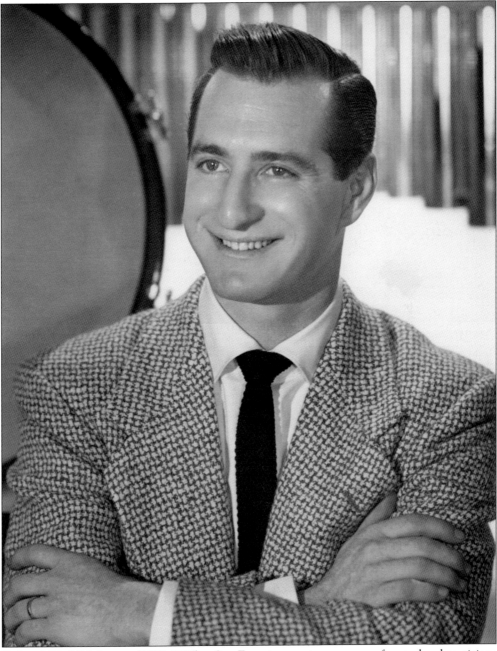

Richard "Dick" Saltzman (1925–2013), a San Francisco native, was one of many local musicians who played with the quartet over the years. Originally a drummer, he learned to play and love the vibraphone. Saltzman also played with Turk Murphy, Cal Tjader, Vince Guaraldi, and Paul Desmond at clubs including the Black Hawk and the Jazz Workshop. (Courtesy of Jean Goldberg.)

CAL TJADER TRIO

701 I V Y
GIVE ME THE SIMPLE LIFE

702 THESE FOOLISH THINGS
702-X CHARLEY'S QUOTE

703 CHOPSTICKS - MAMBO
703-X VIBRA - THARPE

705 LULLABY OF THE LEAVES
705-X THREE LITTLE WORDS

VIDO MUSSO SEXTET

704 CUTTIN' THE NUT
704-X COME BACK TO SORRENTO

"X" Indicates 45 rpm

DOWN BEAT'S CHOICE AMONG BEST RECORDS OF THE YEAR

THESE FOOLISH THINGS

"Cal's trio is first-rate on this release. Tjader shows his elegant, tasteful ballad conception. He's a real comer, with about the best tone of any of the vibists. ...His trio handles this with ease.

CHARLEY'S QUOTE

Cal kicks up a fuss with some more stimulating vibes work, swinging with a happy beat."

JACK TRACY

This Galaxy Records handbill for the Cal Tjader Trio's album from 1952 indicates both Tjader's reputation as a vibes player and the trio's popularity. Recorded over multiple sessions in 1951, the album featured Tjader on vibes, drums, and percussion and Jack Weeks on bass. Vince Guaraldi (1928–1976), known as "Dr. Funk," takes charge of the ivories on four tracks—"Three Little Words," "Ivy," "Chopstix Mambo," and "Vibra-Tharpe." John Marabuto shines on the remaining four tracks. A preview of Tjader's affinity for a Latin sound can be heard on "Chopstix Mambo" and "Ivy." (Courtesy of Derrick Bang.)

Six

JAZZ WOMEN OF SAN FRANCISCO

San Francisco's women in jazz represented a wide and luminous spectrum of backgrounds and talents. From New Orleans–born piano players to dancers turned crooners, local girls and transplants, the city opened her stages to them all. Some women passed through, others got their big breaks here. Some are jazz household names; others, local legends; and all lent their rich sound and effervescent energy to the clubs that made San Francisco jazz shimmy and shake. These are just a few whose lights shone brightly.

Dottie Dodgion was a celebrated drummer at a time when ladies did not play the drums. Originally from Brea, California, Dodgion developed her ear for jazz music at the feet of her father, whose band played San Francisco's "gentlemen's clubs." Late at night, after his postgig dinner at San Francisco landmark Original Joe's, he played records featuring jazz giants like Billie Holliday, Count Basie, and Duke Ellington. "They had so much soul," she remembered, "it used to reach right down deep inside of me. My dad gave me a marvelous start on music." She played with Charlie Mingus in 1947 when he visited the West Coast hoping for a chair with the symphony. Mingus insisted on five-hour rehearsals, which may have daunted another 23-year-old, but Dodgion insisted this period with him taught her more than any other. "It's gotta be all-consuming . . . You've gotta put in the time to get the rewards," she said. She left San Francisco for New York in 1961, where she played stints with Benny Goodman's band and the Marion McPartland Trio.

Pat Yankee (née Weigum; Yankee is her mother's maiden name) commuted from Lodi, California, to San Francisco as a child to tap dance in shows at the Golden Gate Theater. She left for New York City in 1944 at age 15 to continue dance instruction. "I took the train alone. My mother was ok with that; it's what you had to do back in those days." She later signed with Ted Lewis's variety shows and discovered her vocal talent during their East Coast tour. She returned to San Francisco in 1949 and appeared at the Lido and at Bea and Ray Goman's Gay '90s in the International Settlement, located at Pacific between Columbus Avenue and Montgomery Street, and the first hungry i at 599 Jackson in North Beach.

Yankee performed regularly with Turk Murphy's band both at Easy Street and Earthquake McGoon's. Murphy and Yankee met in the mid-1950s when Murphy's band flew to Alaska to play the Fur Rendezvous Festival in Anchorage and for various Army and Navy bases. Pat Yankee (along with an exotic dancer named Suzette) toured with the band to rave reviews. She led several of her own bands, including Pat Yankee and Her Sinners. Yankee was crowned "Empress of Jazz" at Sacramento's Jazz Jubilee (formerly the Dixieland Jazz Jubilee) in 1999. She has performed her one-woman shows—*To Bessie, With Love* and *Remembering Sophie Tucker*—at jazz festivals from Australia to Ireland. She continues to perform today—just as powerfully, if less frequently—at age 87.

Marianne Kent, a regular in the taverns on the oil fields in Alaska, learned the hard way that a woman has to be twice as tough as a man to get half as far. After spending her early 20s in the Alaskan wilds, she returned to San Francisco and continued her cabaret career, singing at such hangouts as the hungry i, where Barbra Streisand often headlined, the Purple Onion, Facks I and II (at 1025 Columbus Avenue, where Bimbo's now stands), and Goman's Gay '90s. She often performed with a big band featuring Jack Tunny on trumpet or with Turk Murphy at Earthquake McGoon's. She has led many of her own bands, including the Reminiscers, Bay City, and her eponymous band.

Norma Louise Teagarden, often described as "the reigning queen of traditional jazz piano," began her professional music career at age 14 and began touring with a band right after high school. She moved to San Francisco in 1957 and played its many clubs both as a solo performer and with local musicians, including Turk Murphy. With her musician brothers Jack (the "Father of Jazz Trombone"), Charlie (on trumpet), Clois Lee "Cubby" (on drums), and their pianist mother, Helen, she played the fifth annual Monterey Jazz Festival in 1963. She taught piano lessons at home until the jarring notes of too many unpolished students led her husband, John Friedlander, to ask her to work nights. She signed on as house pianist for the Washington Square Bar and Grill in North Beach in 1975, where she delighted devoted fans every Wednesday night for two decades. She was also named "Empress of Jazz" at the Sacramento Dixieland Jubilee in 1983. Teagarden passed in 1996 at the age of 85.

Barbara Dane, a Detroit native, moved to San Francisco in 1949 during the heyday of the traditional-jazz revival. Dane's broad appeal stemmed from her crossover approach to song. Trained in opera singing, she navigated folk, jazz, and blues music with equal panache. Dane slipped easily into the local jazz scene, performing with Burt Bales, Bob Mielke, and others. In 1956, Turk Murphy hired her to perform with him and his band at the Tin Angel, her first professional job as a jazz singer. As a vehicle to introduce audiences to the blues, she opened a nightclub called the Sugar Hill: Home of the Blues on Broadway in 1961. Dane was the first American musician to tour in postrevolutionary Cuba, in 1966.

Hociel Thomas was a Texas-born blues and jazz singer and daughter of the storied blues and boogie-woogie pianist George W. Thomas Jr. She moved to New Orleans at age 12 and was raised in Storyville by her aunt, the famed blues singer Sippie Wallace. Wallace had appeared frequently in San Francisco during the Fillmore's first jazz heyday. Thomas and Wallace performed together in New Orleans and then in Chicago, where Thomas recorded with her uncle Hersal Thomas and with Louis Armstrong in 1925–1926.

Thomas led a quiet life for the next 20 years until 1946, when she began performing again in Oakland, California. There, she recorded and performed with Mutt Carey's band and reunited onstage with Kid Ory, with whom she had recorded in Chicago, joining his Creole Orchestra. In a tragic postscript to her promising singing and piano-playing career, Thomas was charged with murder after a fatal fight with one of her sisters. Though she was eventually acquitted, the fight left her blind, and she died two years later in 1952 at age 48.

Other local lights include Wesla Whitfield, Kim Nalley, Bobbe Norris, Denise Perrier, Mary Stallings, LaVay Smith, and Paula West, to name only a very few.

Pat Yankee belts out one of her crowd-pleasing solos at Earthquake McGoon's. (Photograph by Edward Lawless; San Francisco Traditional Jazz Foundation, ARS.0030. Courtesy of the Stanford Archive of Recorded Sound, Stanford University Libraries.)

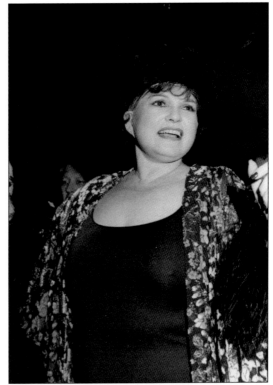

Pat Yankee and Her Sinners pose for a 1962 publicity photograph. Pictured are Bob Burkhart, drums; Art Nortier, piano; Dave Weissbach, banjo; Ernie Carson, trumpet and cornet; Pat Yankee; Bill Caroll, tuba and trombone; and Phil Howe, clarinet. (Courtesy of Pat Yankee.)

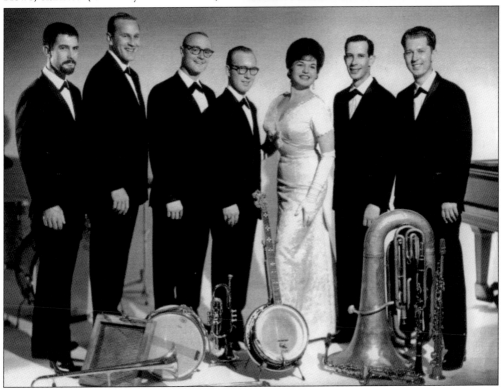

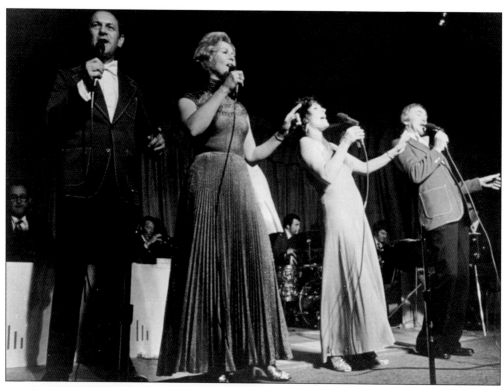

relive the golden years
of the big bands
at the
ST FRANCIS
YACHT CLUB

wednesday february 10

Marianne Kent and the Reminiscers perform together. The Reminiscers include Kent (second from left) as lead singer, Judy Ellen, Norm Bates (left) and Dale Alstrom (right.) Bates also played bass and recorded with Dave Brubeck. Alstrom played saxophone, and he and Ellen have been married for many years. Their daughter Erika leads a jazz band that performs regularly in Marin County, north of San Francisco. (Courtesy of Marianne Kent.)

Private clubs like the St. Francis Yacht Club and the Bohemian Club regularly present music programs for members and guests. Here is a program cover for a show featuring music from the golden years of the big bands, held at the St. Francis Yacht Club. Marianne Kent appeared in many St. Francis shows, often with local trumpeter Walt Tolleson's orchestra. She remains a stage favorite today. (Courtesy of Marianne Kent.)

Here, the evening's entertainment by Marianne Kent and the Walt Tolleson Big Band is described. (Courtesy of Marianne Kent.)

RELIVE
THE GOLDEN YEARS
OF THE BIG BANDS (1938-1945)
at the
ST. FRANCIS YACHT CLUB
WEDNESDAY, FEBRUARY 10

How many of you saw the fabulous Tommy Dorsey stage show, featuring Frank Sinatra and the Pied Pipers . . . danced to Artie Shaw's "Begin the Beguine" . . . crossed the San Francisco Bay Bridge to Treasure Island during the 1939 World's Fair to hear Benny Goodman, the "King of Swing" . . . turned on your radio (your parents *thought* you were sleeping!) to tune in an announcer saying: "And now, from Frank Dailey's Meadowbrook, on scenic Route 22, we bring you Glenn Miller and His Orchestra, featuring Tex Beneke and the Modernaires, with their new hit, "Chattanooga Choo Choo" . . . attended a wild "Jam Session" that lasted until the wee hours of the morning . . . ???

As the curtain opens, WALT TOLLESON'S BIG BAND plays an overture of the nostalgic theme songs of Glenn Miller, Tommy Dorsey, Harry James, Artie Shaw, Duke Ellington, and Benny Goodman. "Praise the Lord and pass the Ammunition" kicks off a salute to the emotional songs of World War II, the REMINISCERS will bring forth a tear or two with "I'll Never Smile Again", and MARIANNE KENT duplicates the vocal styles of Wee Bonnie Baker and Helen O'Connell as "Oh Johnny" and "Those Cool and Limpid Green Eyes" sparkle again.

There's a lot more . . . Spike Jones, Ina Ray Hutton, Sammy Kaye, and others all come to life again.

The price per person including dinner, wine, and show is $7. Please respond early as our seating capacity is limited to 325 members and guests. Not more than four guests per member.

Cocktails 6:00 Dinner 7:00
 Curtain Time 8:30

Marianne Kent and the Lower Market Street Boys enjoy the fun during their performance. (Courtesy of Marianne Kent.)

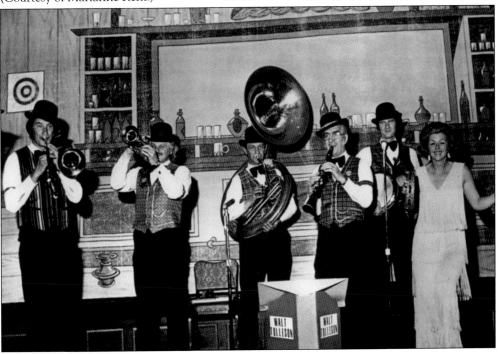

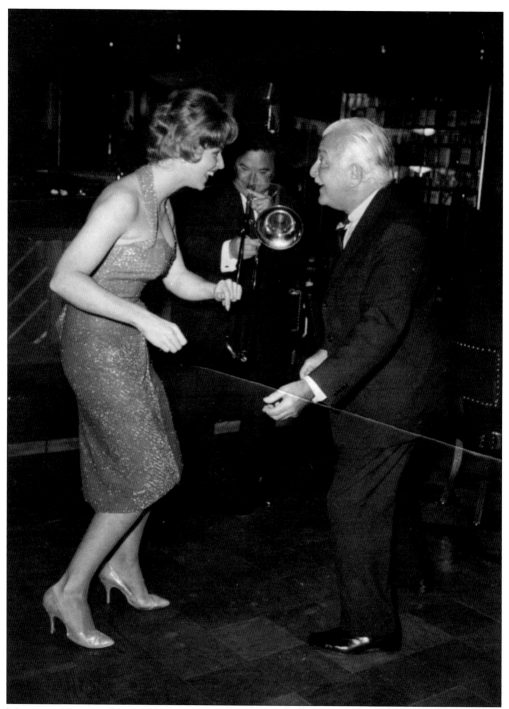

Marianne Kent teaches Arthur Fiedler to dance the twist at Bimbo's 365 in North Beach. Kent appeared in celebration of the opening of Bimbo's Twist Room. Legendary bandleader Fiedler was in the audience. The two shared a dance that night that made headlines. (Courtesy of Marianne Kent.)

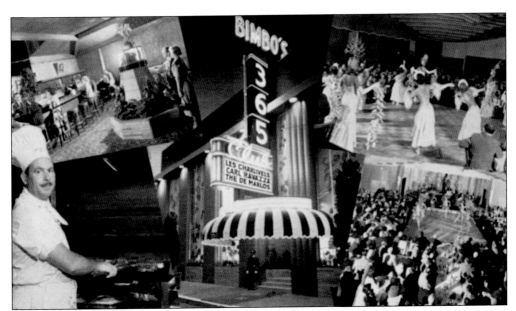

The Bimbo's 365 marquee blazes and reflects the energy inside. Bimbo's, a family-owned club, moved from its 365 Market Street location to 1025 Columbus Avenue in North Beach in 1951, replacing the Bal Tabarin. Both clubs opened in the 1930s. (Courtesy of *San Francisco Art Deco* by Michael F. Crowe and Robert W. Bowen.)

Bimbo's 365 has featured musical acts from the mainstream to the esoteric for over 80 years. The club's name combines founding co-owner (with Monk Young) Agostino Giuntoli's nickname "Bimbo"—the Italian diminutive for *boy*—and its original address. (Courtesy of Harley Bruce Photography.)

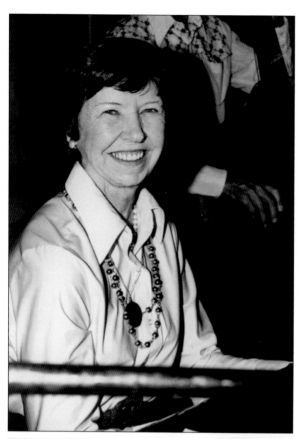

Norma Teagarden was known as "the reigning queen of traditional jazz piano." (Photograph by Edward Lawless; San Francisco Traditional Jazz Foundation, ARS.0030. Courtesy of the Stanford Archive of Recorded Sound, Stanford University Libraries.)

Teagarden performs onstage with Wingey Manone and his All Star Band at the October 1975 Jazz Band Ball. (Photograph by Edward Lawless; San Francisco Traditional Jazz Foundation, ARS.0030. Courtesy of the Stanford Archive of Recorded Sound, Stanford University Libraries.)

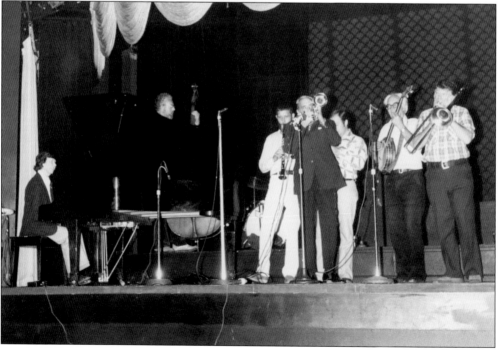

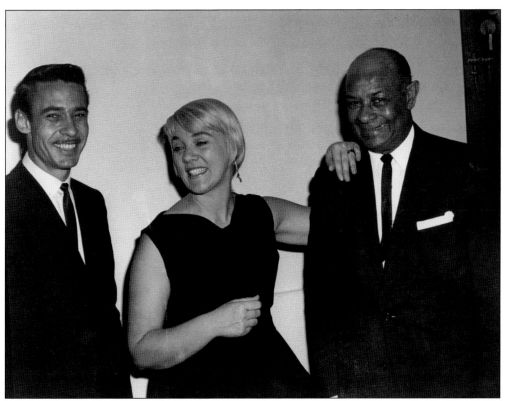

Barbara Dane is pictured with friends and bandmates—the pianist, trumpeter, and vocalist Kenny Whitson (left) and bassist Wellman Braud. Dane cites both Sippie Wallace and Hociel Thomas as vocalists who influenced her work. (Photograph by William Carter; San Francisco Traditional Jazz Foundation, ARS.0030. Courtesy of the Stanford Archive of Recorded Sound, Stanford University Libraries.)

BAYSIDE JAZZ SOCIETY

Presents

HOCIEL THOMAS

Blues Singer Formerly with Louis Armstrong

and the

POLECATS

	Friday, February 23, 1951
JENNY LIND HALL	9 Til 1
2229 Telegraph Avenue	Admission $1.00
Oakland	BJS Members .75

Here is an announcement for a performance featuring Hociel Thomas and the Polecats. (San Francisco Traditional Jazz Foundation, ARS.0030. Courtesy of the Stanford Archive of Recorded Sound, Stanford University Libraries.)

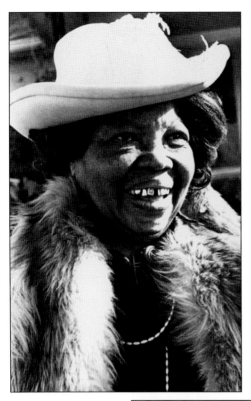

Sippie Wallace (née Beulah Thomas, 1989–1986), "the Texas Nightingale," who was an accomplished blues and gospel singer-songwriter herself, raised and performed with Hociel Thomas during their Chicago years. Her career spanned four decades, during which she shared the stage with legends from Louis Armstrong to B.B. King. After Thomas died, Wallace helped to raise her original charge's child as well. (San Francisco Traditional Jazz Foundation, ARS.0030. Courtesy of the Stanford Archive of Recorded Sound, Stanford University Libraries.)

Mutt Carey Plays the Blues with Hociel Thomas was recorded in San Francisco by Riverside Records in 1946 as part of Rudi Blesh's project to capture the sounds of early jazz tunes. Despite his long career onstage, Thomas "Papa Mutt" Carey (1891–1948) rarely recorded other than as a sideman for Kid Ory; this is his only feature LP. (Author's collection.)

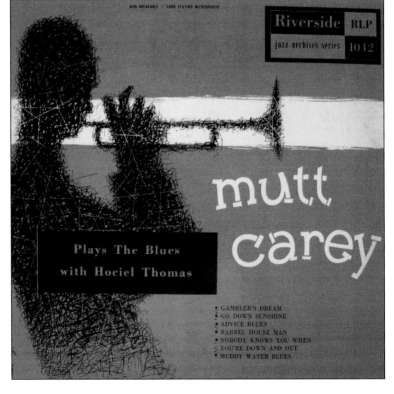

Jazz and blues singer Claire Austin (née Augusta Marie, 1918–1994) hailed from Yakima, Washington. Her deep, lush voice has been compared to Peggy Lee's. She recorded with Bob Scobey, Kid Ory, and Shelly Manne, among others. (Photograph by Edward Lawless; San Francisco Traditional Jazz Foundation, ARS.0030. Courtesy of the Stanford Archive of Recorded Sound, Stanford University Libraries.)

An advertisement announces Claire Austin's first San Francisco appearance in 1952; she is on the bill with Turk Murphy's Jazz Band at the Italian Village. (San Francisco Traditional Jazz Foundation, ARS.0030. Courtesy of the Stanford Archive of Recorded Sound, Stanford University Libraries.)

Claire Austin shares a beverage with Turk Murphy and friends during her visit to New Orleans in the mid-1950s. Pictured, clockwise from left, are two unidentified men, Doc and Mrs. Evans, Bill Carter, Thad Vandon, Pete Clute, George Avakian, Margo Reiman, Murphy, and Austin. (San Francisco Traditional Jazz Foundation, ARS.0030. Courtesy of the Stanford Archive of Recorded Sound, Stanford University Libraries.)

Kim Rene Nalley sings jazz, the blues, R & B, gospel, and Gershwin. She moved to San Francisco from the East Coast to study history at the University of California, Berkeley, and is currently pursuing a doctorate there on the globalization of jazz and black cultural politics. With her versatility and her three-and-a-half-octave range, Nalley has kept San Francisco audiences rapt whether performing at the Bach Dancing & Dynamite Society or with Michael Tilson Thomas and the San Francisco Symphony. (Courtesy of *African Americans of San Francisco* by Jan Batiste Adkins, per Kim Nalley.)

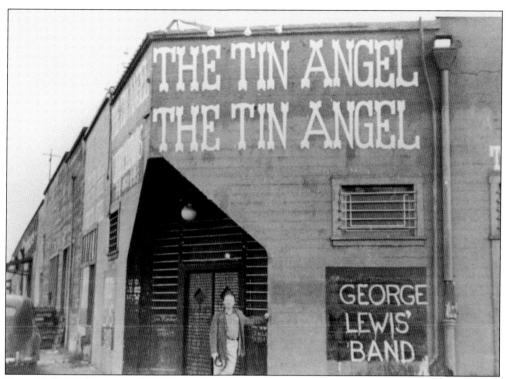

Peggy Tolk-Watkins owned the Tin Angel, across from Pier 23 at 981 Embarcadero, for five years before turning it over to Kid Ory. Ory changed the name to On the Levee and continued to present jazz music here until he sold the club in August 1961 and moved to Los Angeles. (San Francisco Traditional Jazz Foundation, ARS.0030. Courtesy of the Stanford Archive of Recorded Sound, Stanford University Libraries.)

This is an advertising graphic for the Italian Village, located at 915 Columbus Avenue, where Turk Murphy often performed with his band in the 1950s before he opened Earthquake McGoon's in 1960. The band recorded *Turk Murphy's Jazz Band at the Italian Village* here in 1953. (San Francisco Traditional Jazz Foundation, ARS.0030. Courtesy of the Stanford Archive of Recorded Sound, Stanford University Libraries.)

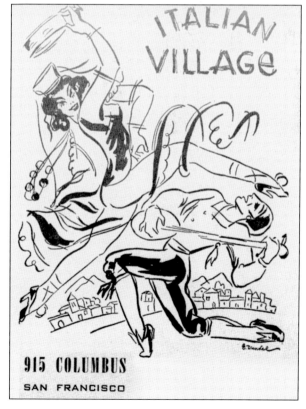

This image shows patrons at Murphy's Earthquake McGoon's in the 1970s. The artwork in the background displays scenes from Carter the Magnificent's feats of magic. (San Francisco Traditional Jazz Foundation, ARS.0030. Courtesy of the Stanford Archive of Recorded Sound, Stanford University Libraries.)

Bimbo's 365 served as the venue for the Fifth Annual Trad Jazz Jamboree. (Photograph by Edward Lawless; San Francisco Traditional Jazz Foundation, ARS.0030. Courtesy of the Stanford Archive of Recorded Sound, Stanford University Libraries.)

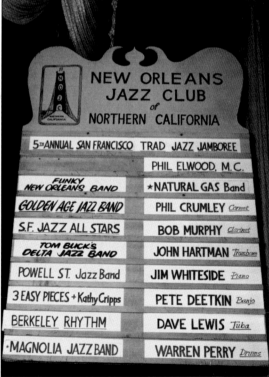

This is the line-up for the jamboree, emceed by Phil Elwood and brought to the stage by the New Orleans Jazz Club of Northern California. (Photograph by Edward Lawless; San Francisco Traditional Jazz Foundation, ARS.0030. Courtesy of the Stanford Archive of Recorded Sound, Stanford University Libraries.)

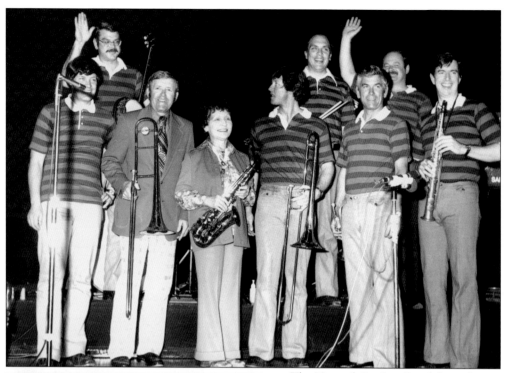

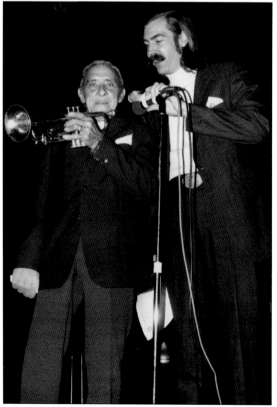

The Natural Gas Jazz Band formed in 1970 in the image of Lu Watters and Turk Murphy. The band has toured and recorded extensively and continues to perform in 2014. Carl Lunsford, a banjo player with Murphy's band, currently performs with the Natural Gas Jazz Band. (Photograph by Edward Lawless; San Francisco Traditional Jazz Foundation, ARS.0030. Courtesy of the Stanford Archive of Recorded Sound, Stanford University Libraries.)

Wingey Manone (left) is assisted at the microphone during his appearance as a special guest at Bimbo's in October 1975 with Jim Watt, of the Traditional Jazz Platters, in a performance for station KMPX. (Photograph by Edward Lawless; San Francisco Traditional Jazz Foundation, ARS.0030. Courtesy of the Stanford Archive of Recorded Sound, Stanford University Libraries.)

This is a program from the San Francisco Symphony Association benefit for the pension fund featuring a Dixieland Ragtime Jamboree held at the civic auditorium with Wally Rose, Burt Bales, Earl "Fatha" Hines, Kid Ory's Creole Band, and more. The Bill Graham Civic Auditorium holds 6,000 people, so it is not a club per se, but musical acts continue to perform there today. (Both, San Francisco Traditional Jazz Foundation, ARS.0030. Courtesy of the Stanford Archive of Recorded Sound, Stanford University Libraries.)

San Francisco Symphony Orchestra
ENRIQUE JORDÁ, Conductor

DIXIELAND RAGTIME JAMBOREE

BENEFIT PENSION FUND

SUNDAY EVENING, MARCH 3, 1957

8:00 o'clock

SAN FRANCISCO CIVIC AUDITORIUM

Presented by

San Francisco Symphony Association

KENNETH MONTEAGLE
President

HOWARD K. SKINNER
Manager

Produced by Charley Stern — California Productions

PROGRAM

MASTER OF CEREMONIES — HAWTHORNE

THE SAN FRANCISCO SYMPHONY ORCHESTRA
EARL MURRAY, Associate Conductor

Dances from "Fancy Free" . Leonard Bernstein

The composer demonstrates in vivid fashion, the influence
of jazz music on a symphonic composition

WALLY ROSE'S DIXIELAND BAND
ALLIE LORRAINE, Vocalist

| Dixieland One Step | Dippermouth Blues |
| Tin Roof Blues | Black and White Rag |

RAGTIME PIANIST BURT BALES

PHILIP KARP, Bass
LLOYD DAVIS, Percussion } Symphony Members

| King Porter Stomp | Blues by Burt Bales |
| Maple Leaf Rag | |

EARL "FATHA" HINES AND THE ALL STARS

The World Is Waiting for the Sunrise
| Honeysuckle Rose | St. Louis Blues |
| Darktown Strutters Ball | |

INTERMISSION

BAY CITY JAZZ BAND
SANFORD NEWBAUER, Director

| Yerba Buena Strut | Alligator Blues |
| Come Back Sweet Papa | Yerba Buena Blues |

PIANIST JOE SULLIVAN

| Little Rock Get Away | That's A-Plenty |
| Gin Mill Blues | |

KID ORY'S CREOLE JAZZ BAND

MARVIN NELSON, Trumpet
PHILIP KARP, Bass
LLOYD DAVIS, Percussion } Symphony Members

| Muskrat Ramble | High Society |
| Savoy Blues | |

BOB SCOBEY'S FRISCO JAZZ BAND
Augmented by

MARVIN NELSON, Trumpet
PHILIP KARP, Bass
PHILIP LASPINA, Trombone } Symphony Members
CLANCY HAYES, Vocalist and RALPH SUTTON, Pianist

Waiting for the Robert E. Lee	When the Saints Come Marchin In
Canadian Capers	Ace in the Hole
New Orleans	Hobson Street Blues

THE SAN FRANCISCO SYMPHONY ORCHESTRA
ENRIQUE JORDA, Conductor

RHAPSODY IN BLUE . George Gershwin
WALLY ROSE, Pianist

The jazz musicians will take their places in key solo
positions within the Symphony Orchestra

Baldwin Pianos

The San Francisco Symphony Association extends its sincere appreciation to all
who have so generously contributed to the success of this unique presentation.

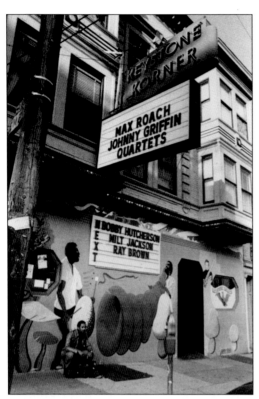

Keystone Korner's exterior announces the venue's current and upcoming acts. (Courtesy of Brian McMillen.)

Here is another view of the club's exterior and marquees that promise more tremendous talent inside. (Courtesy of Todd Barkan.)

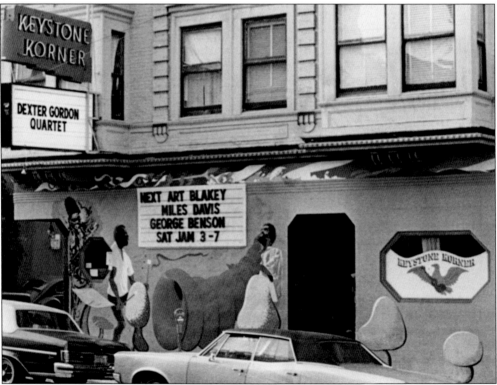

750 Vallejo Street in North Beach, the former home of Keystone Korner, is now a Chinese restaurant. (Courtesy of Harley Bruce Photography.)

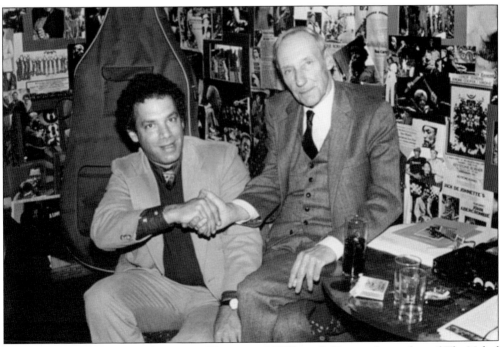

Todd Barkan (left), owner of Keystone Korner, and William S. Burroughs, author of *The Naked Lunch*, are pictured after Burroughs gave a reading from his work to a jazz accompaniment in 1980. Allen Ginsberg also read from "Howl" at Keystone to the saxophone strains of Stan Getz. (Courtesy of Todd Barkan.)

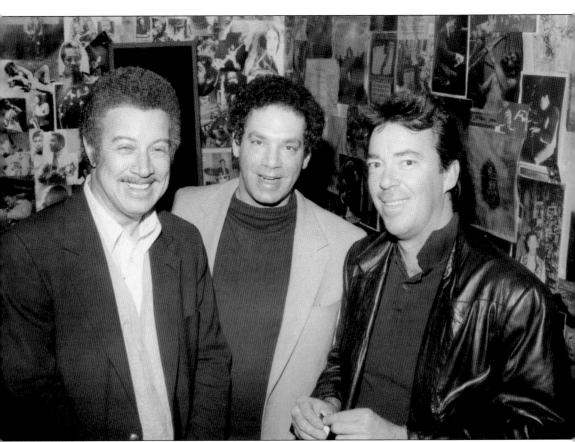

From left to right, Kenneth Earl "Kenny" Burrell (born in 1931), Todd Barkan, and Boz Scaggs pose together at Keystone Korner. Burrell, named a jazz master by the National Endowment for the Arts in 2005, has recorded hundreds of albums, either alone or with icons ranging from Ellington to Coltrane. A guitarist, composer, and jazz historian, Burrell has graced stages since 1956. He is a professor of music and ethnomusicology at the University of California, Los Angeles. William Royce "Boz" Scaggs (born in 1944) came to San Francisco in 1967, lured by a burgeoning blues scene. Though guitar player and vocalist Scaggs does not consider himself a jazz artist, he released two critically acclaimed recordings of jazz standards in the early 2000s. He is a co-owner of the Great American Music Hall and a founding partner of live-music venue Slim's, and he tours with Donald Fagen (Steely Dan) and Michael McDonald (the Doobie Brothers) as the Dukes of September Rhythm Review. Scaggs and his wife, Dominique, own Scaggs Vineyard in Napa Valley. (Courtesy of Brian McMillen.)

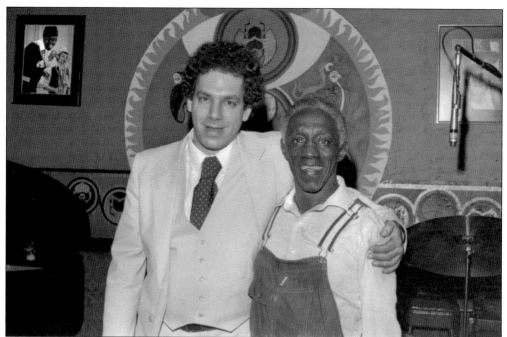

Todd Barkan (left) and Art Blakey pose for a photograph together. Blakey, a jazz drummer and bandleader, and his Jazz Messengers performed often at Keystone and recorded three albums—*In This Korner* (1978), *Straight Ahead* (1981), and *Keystone 3* (1982)—all for the Concord Jazz label. (Courtesy of Brian McMillen.)

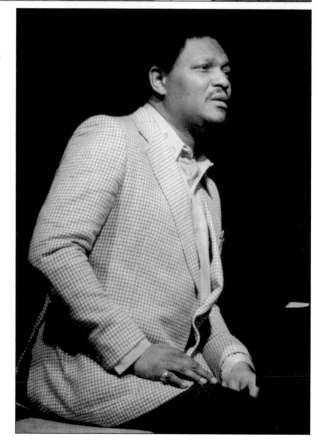

McCoy Tyner recorded *Atlantis* at Keystone in 1974. The legendary pianist worked with John Coltrane and as a solo artist. (Courtesy of Brian McMillen.)

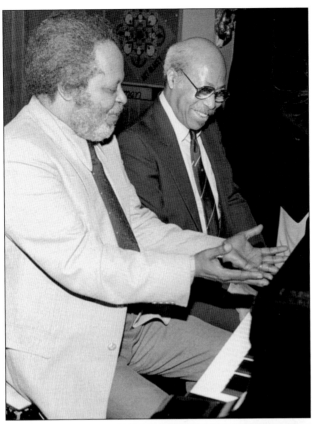

Jaki Byard (left) and Tommy Flanagan sit at the piano at Keystone during their 1982 appearance. (Courtesy of Todd Barkan.)

Jazz guitarist Pat Metheny is pictured at Keystone in 1980. (Courtesy of Brian McMillen.)

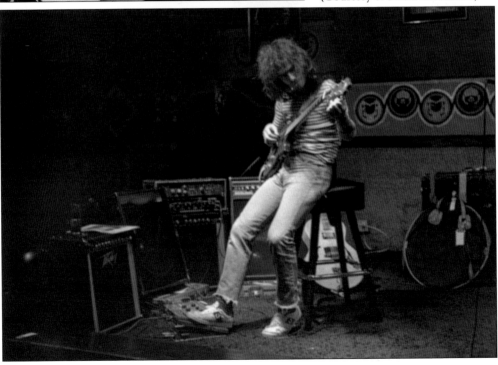

Seen here is Earl "Fatha" Hines, who inspired generations of jazz pianists, at Keystone. Dizzy Gillespie and Charlie Parker both played in Hines's bands, and Louis Armstrong was a colleague and friend. (Courtesy of Brian McMillen.)

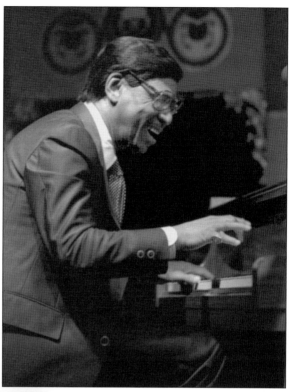

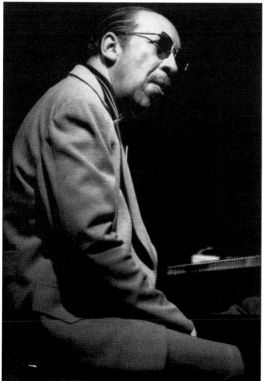

Red Garland is pictured at Keystone in 1978. Another seminal jazz pianist who influenced future musicians, Garland joined the Miles Davis Quintet in 1955 when Coltrane was a fellow bandmate. Garland entertained a brief career as a welterweight boxer in his youth and fought Sugar Ray Robinson. The experience did not compromise his pianist's hands. (Courtesy of Brian McMillen.)

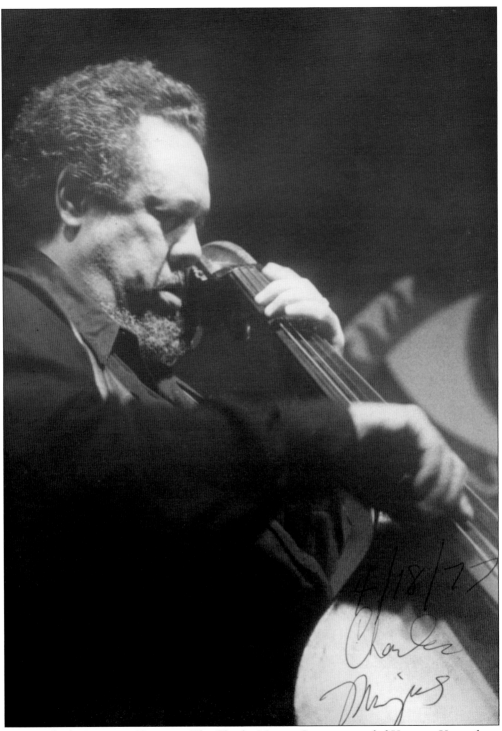

Here is Charlie Mingus at Keystone. The Charlie Mingus Quintet recorded *Keystone Korner* here for Jazz Door (Italy) in 1976. (Courtesy of Ira Zalesin.)

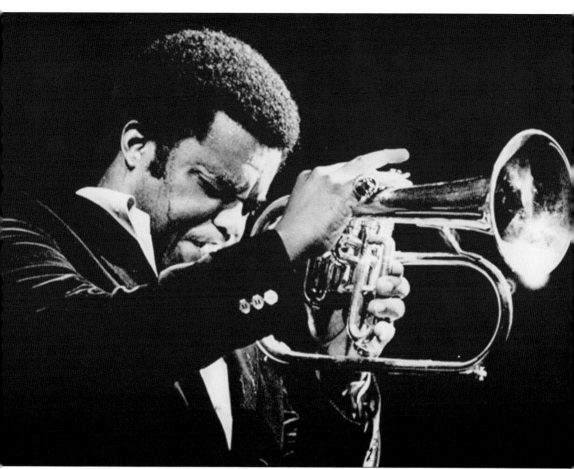

Trumpeter Freddie Hubbard is shown at the Great American Music Hall (GAMH) in 1978. The GAMH remains a favorite music venue in San Francisco. Hubbard recorded four albums at Keystone Korner between November 1981 and June 1982: *Classics*, *Keystone Bop*, *A Little Night Music*, all for Fantasy-F, and *Above & Beyond* for Metropolitan. (Courtesy of Brian McMillen.)

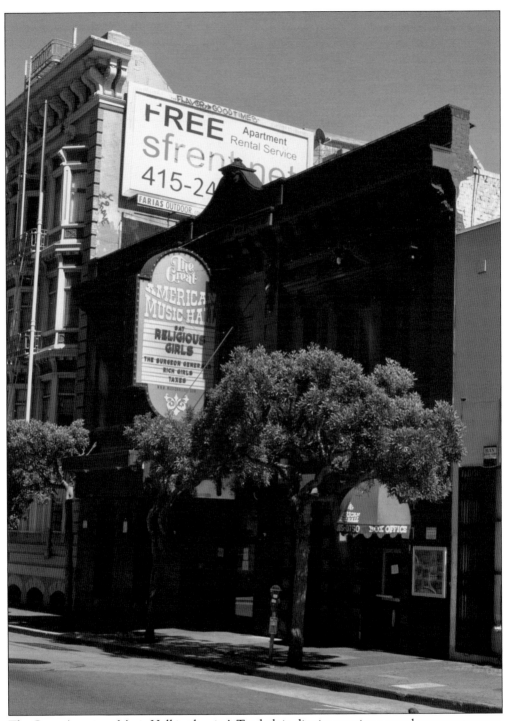

The Great American Music Hall in the city's Tenderloin district remains a popular concert venue. (Courtesy of Harley Bruce Photography.)

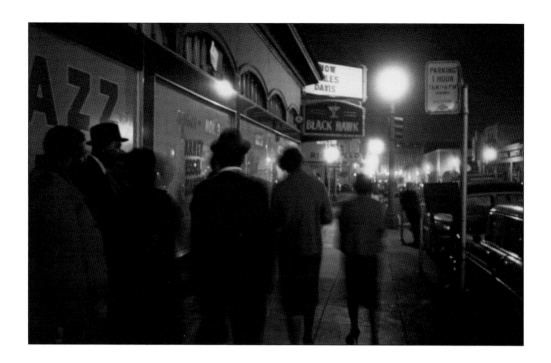

The iconic Black Hawk, the arguable epicenter of the jazz scene in San Francisco in the 1950s early 1960s, featured such legends as trumpeter Miles Davis, homegrown vibes player Cal Tjader, and pianist Marian McPartland. These images depict the exterior of the building at the corner of Turk and Hyde Streets, and the interior bar area. The rear of the club also contained a "cage" constructed of chicken wire to separate teenage jazz fans from the this part of the venue, where alcohol freely flowed. (Photographs © Jerry Stoll Photography.)

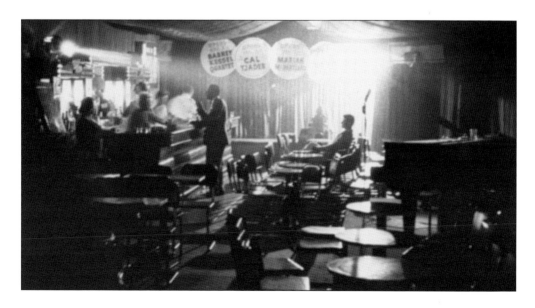

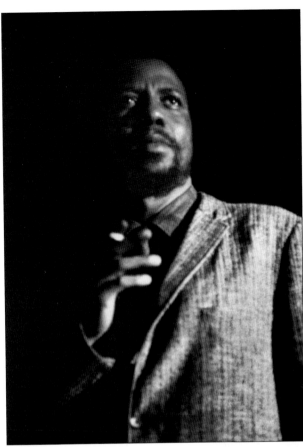

A pensive Thelonious Sphere Monk (1917–1982) appears onstage during an appearance at the Black Hawk. Monk, a pianist, composer, and innovator, helped create the type of jazz known as "bebop" with other famed musicians like Charlie Parker. Along with Dave Brubeck, Monk is one of five jazz musicians to have appeared on the cover of *Time* magazine. The Thelonious Monk Institute of Jazz in Washington, DC, sponsors an annual International Jazz Competition to identify and nurture new jazz musicians. (Photograph © Jerry Stoll Photography.)

The site of the Black Hawk is today a forlorn parking lot in the Tenderloin district. (Courtesy of Harley Bruce Photography.)

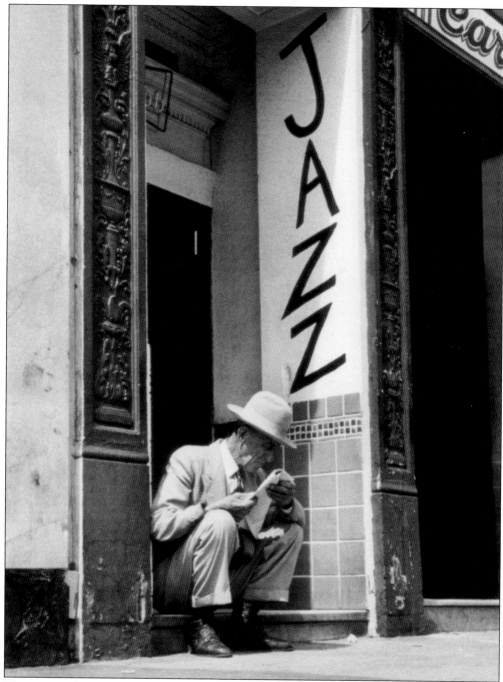

The exterior doorway of the Cellar, located at 576 Green Street at Columbus Avenue, was founded in 1957 by poets Lawrence Ferlinghetti (owner of the renowned Columbus Avenue bookstore City Lights) and Kenneth Rexroth to provide a venue for jazz and poetry to commune. The pair recorded a poetry reading with the Cellar Jazz Quintet for Fantasy Records that year, but the public's appetite for a jazz/poetry nightclub proved spare and the Cellar closed shortly thereafter. (Photograph © Jerry Stoll Photography.)

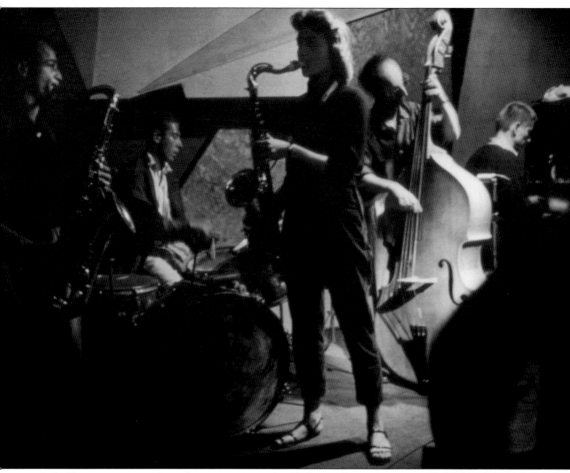

Judy Tristano appeared on the tenor sax at the Cellar and on occasion with husband Leonard Joseph "Lennie" Tristano's ensembles on vocals. Lennie was a controversial jazz figure known for embracing free improvisation and playing the music he felt. A contemporary and friend of Charlie Parker, Lennie taught piano for over three decades and attained a certain notoriety for his outspoken criticism of the music industry. (Photograph © Jerry Stoll Photography.)

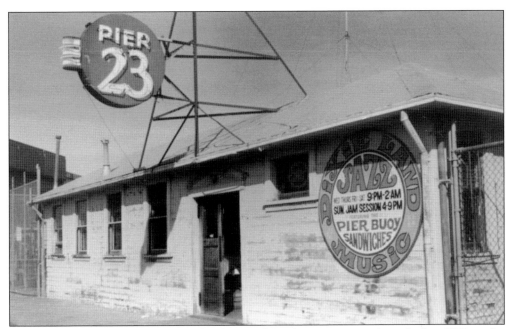

Pier 23, at its rustic best, hosted Dixieland jazz and Sunday jam sessions from the late 1950s to the mid-1960s. These were recorded and can be heard today on jazzhotbigstep.com. (San Francisco Traditional Jazz Foundation, ARS.0030. Courtesy of the Stanford Archive of Recorded Sound, Stanford University Libraries.)

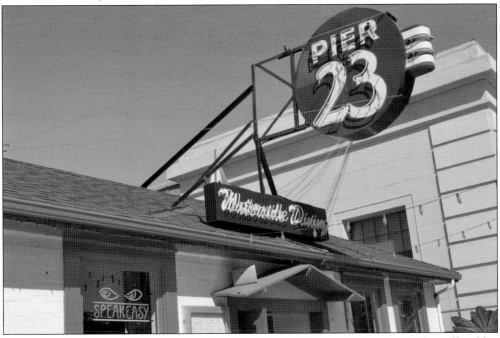

Pier 23 on the Embarcadero remains a favorite with music lovers. When Burt Bales suffered his injury, Bill Erickson took over the piano stool at Pier 23 and performed with the usual local musicians, like Bob Mielke, Dick Oxtot, and Frank "Big Boy" Goudie. (Courtesy of Harley Bruce Photography.)

The Hungry I Club is at 546 Broadway. The original hungry i stood at 599 Jackson Street. Club owner Enrico Banducci sold the name to a strip club when he closed the business in the mid-1960s. In addition to featuring jazz singers such as Vince Guaraldi, Banducci booked Barbra Streisand before her star blazed, as well as comedians such as Lenny Bruce and Mort Sahl. (Courtesy of Harley Bruce Photography.)

The current Hungry I shares corners with the Beat Museum. (Courtesy of Harley Bruce Photography.)

The Condor, where Carol Doda revolutionized San Francisco's nightscape, anchors the block where the Hungry I is located. (Courtesy of Harley Bruce Photography.)

473 Broadway today houses Monroe, a hip private-event venue. Monroe is steeped in memories of all the talents who performed at the Jazz Workshop in the 1960s. (Courtesy of Harley Bruce Photography.)

The next chapter of San Francisco's jazz history will be written at Randall Kline's brainchild, SFJAZZ at Franklin and Fell Streets in the city's Civic Center neighborhood. (Courtesy of Harley Bruce Photography.)

First opened in January 2013, SFJAZZ maintains a full calendar of every subgenre of jazz music. Over 10,000 jazz lovers have become members since the facility opened. (Courtesy of Harley Bruce Photography.)

Eight

Communing with Jazz at the Bach

The Bach Dancing & Dynamite Society is a nearly 50-year-old institution located inside the Douglas Beach House south of San Francisco on the Pacific Ocean in Miramar. Through economic strife, landslides that often eliminated access to the coast, and fans' fickleness, one man's love of jazz and chamber music performed in the intimate venue he created and coddled reminds all who made the trek "over the mountain" that jazz is more than notes and tunes.

Owner Pete Douglas's half century spent in the salt air etched his skin and left him craggy and weathered. His trademark beanie and sunglasses and the pipe constantly clenched between stubby, tobacco-streaked teeth announced his pure Beat vibe. Douglas fell into his role as concert promoter after stints as a social worker and mortgage broker, though he would have been loath to call himself a promoter at all; he claimed that he just provides a place for musicians to do what they do best and for the audience to experience music not as passive listeners but as participants engaged in a dialogue with the performers.

There is no opportunity for musician-audience dialogue in a coliseum. It is hard to communicate with musicians who are so far away they resemble lawn gnomes, and worse if they can only be made out as a pixilated blur on the big screen. Sounds are distorted by speakers the size of Kansas. Audience members who stand up to groove are booed by the people seated behind them. Often, it seems that fans might just as well stay home and watch the concert on a big-screen television.

Douglas bought the house in the late 1950s, his retreat from those suburban straightjacket jobs. As friends and strangers gathered to watch the sunset one night, he turned on the Brandenburg Concertos. Couples met at the water's edge, swaying to the music. In the mellow afterglow of a few joints, someone lit a fistful of fireworks, and thus was born the Bach Dancing & Dynamite Society.

The house has not changed much since Douglas bought the place. He added the upper floors in the 1970s to accommodate the increasing numbers of people who had heard about his weekend music scene and crossed the hill to hear and feel the magic. In an unprepossessing, oversized

living room with exposed beams, indoor-outdoor carpeting, "stained-glass" clerestories, and a raft of windows looking out over the sea, visitors meet the artist in the middle and learn that a piano solo or a saxophone cadenza can break the heart.

Since its accidental, incendiary beginning, the rough-hewn walls of the Douglas Beach House (DBH) have thrummed, mostly featuring jazz artists, but with funk, R & B, and chamber musicians taking the stage as well. Within these walls, the emotional pulse of jazz beckons the listener to come close, to close his or her eyes, to feel the rhythm.

The chairs at the DBH sit arrayed in short lines, 10 rows deep, which places patron and musician close together. The audience can see the sweat on a sax player's lip and the calluses on a bass player's nimble fingertips, feel the sensual sway in a trumpeter's hips, hear the "shoop shoop" of brush on drum from the drummer with the bulging biceps, and play air piano with the musician whose fingers fly across the ivories. Spectators weave themselves into the tapestry of the song. Passive listeners miss the point.

Every jazz great from the past half century has passed through Pete Douglas's sliding glass door. Scanning the list of musicians who have played here—Dizzy Gillespie, Toots Thielman, Stan Getz, Terrence Blanchard, Dexter Gordon, Cindy Lewis, McCoy Tyner, and the Brubeck Brothers among them—one might wonder whether Leonard Feather, author of *The Encyclopedia of Jazz*, used the roster as a research tool. If the Douglas Beach House walls could talk, could play back every riff and root, jazz standard, call-and-response, and blues improv, those walls would erupt in a fantasy fugue that would coax the angels down from on high. The music world bid farewell to Pete Douglas on July 12, 2014.

Pete Douglas, jaunty cap in place, is pictured around 1960. (Courtesy of Pete Douglas.)

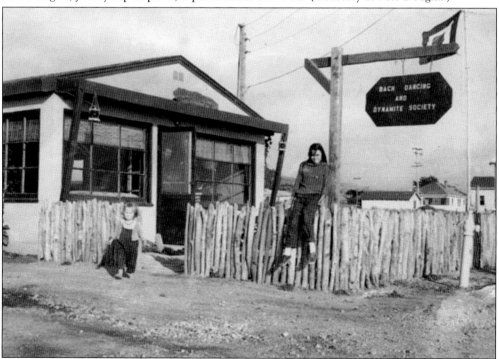

The first sign went up, and the Bach was open for business. Pete's daughters pose out front in the early 1960s. (Courtesy of Pete Douglas.)

The flags flying in front of the Bach reflect the nationalities of the performers. (Courtesy of Pete Douglas.)

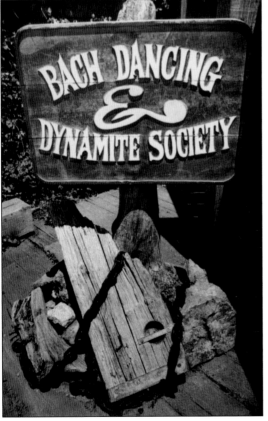

A carved sign welcomes guests to the Bach Dancing & Dynamite Society on Miramar Road. Flotsam from the beach beneath the frontage road adorns its base. (Courtesy of Brian McMillen.)

Tenor saxophone and flute player Lew Tabackin (born in 1940) started playing in New York's jazz clubs in the 1960s. He counts Sonny Rollins and John Coltrane among his most powerful influences. He is married to jazz pianist Toshiko Akiyoshi, and the couple founded the Toshiko Akiyoshi Jazz Orchestra. Tabackin tours as a solo artist, with small combos, and with the orchestra. (Courtesy of Brian McMillen.)

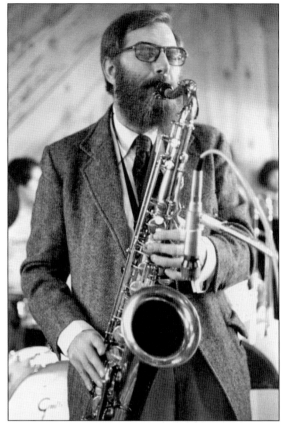

This is the view over the Pacific from the picnic porch. Many a Sunday afternoon was passed sipping wine and nibbling delectables while listening to the waves crash and waiting for the music to begin. (Courtesy of Pete Douglas.)

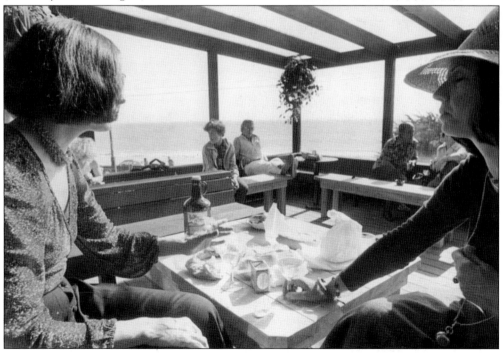

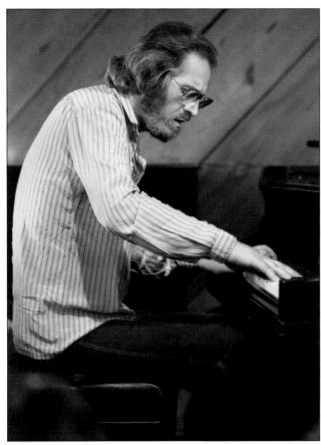

Bill Evans (1929–1980) tempts a sensitive, soul-searing sound from the Steinway. Evans played with Miles Davis early in his career, then performed and recorded in trios or as a soloist until his premature death in 1980 at age 51. His 1960 tour included an appearance at the Jazz Workshop. Evans garnered 31 Grammy nominations, seven wins, and a Lifetime Achievement Award. He is considered equal to McCoy Tyner in terms of his influence on and inspiration of other jazz pianists. (Courtesy of Brian McMillen.)

Art Blakey, pictured here at the drum kit, said, "You don't have to be a musician to understand jazz. All you have to do is be able to feel." (Courtesy of Brian McMillen.)

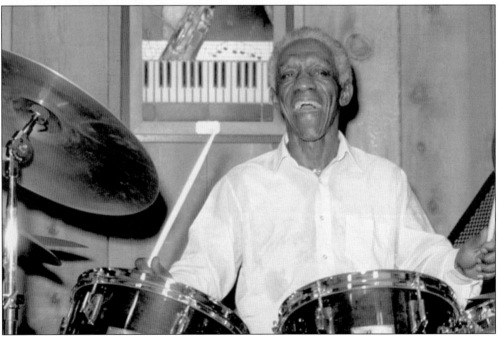

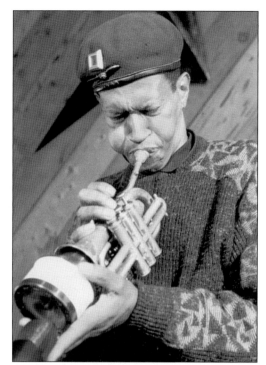

Don Cherry (1936–1995) is pictured on trumpet. Cherry and saxophone player Ornette Coleman figured prominently in the avant-garde/free-jazz movements of the 1950s and 1960s. He continued to evolve during the postmodern era, incorporating African sounds and other world beats into his music. "When people believe in boundaries, they become part of them," he said. (Both, courtesy of Brian McMillen.)

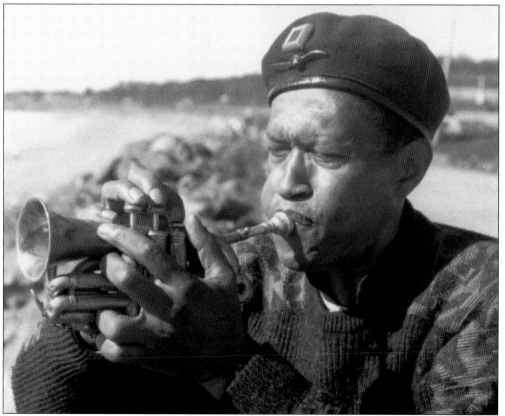

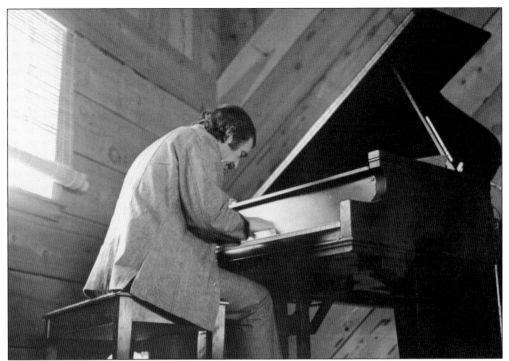

Many a pianist has caressed the keys of the Steinway at the Bach, including this rapt pianist. Another pianist who performed at the Bach, Chopin master Thomas Tobing from Paris, called the instrument "rare," saying, "My music will not sound this magical on any other piano." The Steinway dates from 1906 and came to the Bach from the San Francisco Opera, where it may once have accompanied Italian tenor Enrico Caruso. (Courtesy of Brian McMillen.)

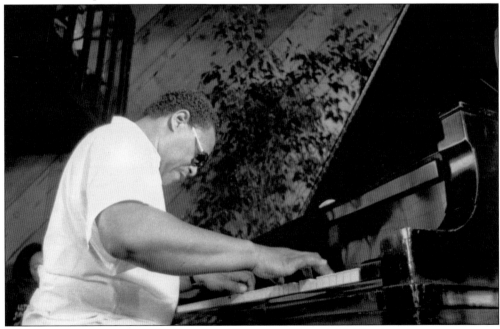

McCoy Tyner takes a seat at the Steinway. (Courtesy of Brian McMillen.)

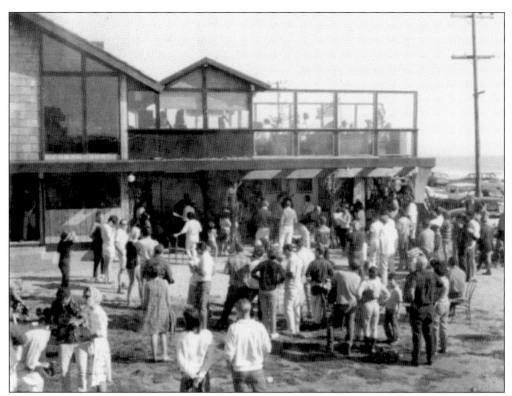

Crowds spill into the shell-strewn street and vacant lot during an afternoon concert in the 1960s. (Courtesy of Pete Douglas.)

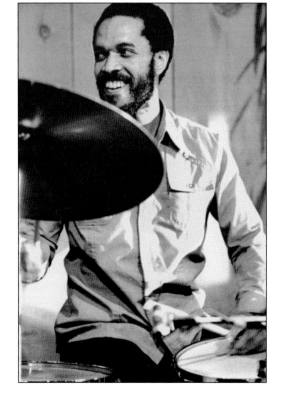

Billy Higgins (1936–2001), considered one of greatest jazz drummers, played on more than 700 recordings, including rock and funk albums. He started with Ornette Coleman in the late 1950s, recorded with Thelonious Monk at the Black Hawk in 1960, and continued recording until his death in 2001. Higgins also taught jazz studies at the University of California, Los Angeles. (Courtesy of Brian McMillen.)

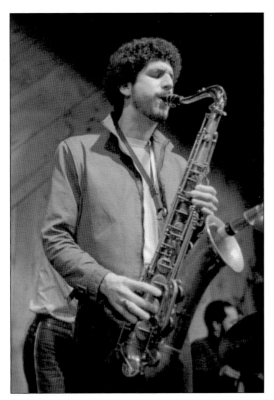

Bob Berg (1951–2002) is shown on tenor sax with Cedar Walton's quartet. Berg recorded a single album with Miles Davis's band, multiple solo albums, and a number of recordings with others, including Horace Silver, John Birks "Dizzy" Gillespie, and Chick Corea. He played hard bop as well as a mélange of jazz, funk, and sometimes country. Berg was killed in an automobile accident at age 51. (Courtesy of Brian McMillen.)

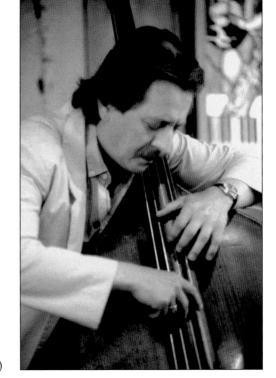

George Mraz (born in 1944) plays both jazz bass and alto saxophone. Mraz has recorded with countless talents, including Oscar Peterson, John Haley "Zoot" Sims, and McCoy Tyner. (Courtesy of Brian McMillen.)

Joe Henderson's (1937–2001) nearly 40-year career as a tenor saxophone player saw him perform and record with multiple labels and artists. He had a brief stint with rock group Blood, Sweat & Tears. His versatility is reflected in recordings ranging from hard bop to more experimental jazz fusion. He moved to San Francisco in 1971. (Courtesy of Brian McMillen.)

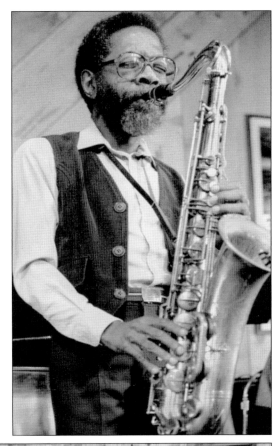

The living room at the Bach is another locus of gathering before a concert and during intermission. (Courtesy of Pete Douglas.)

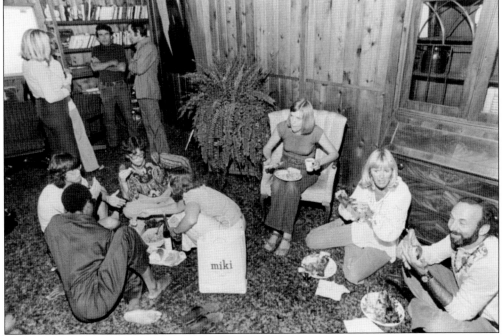

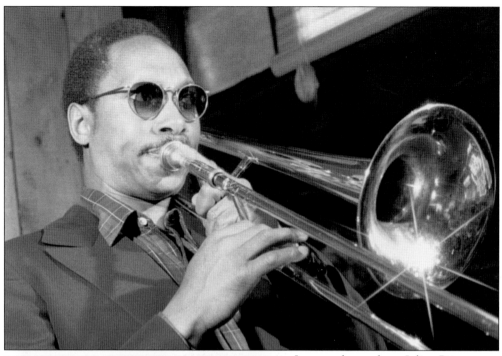

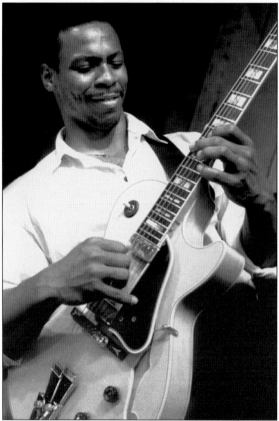

Jazz trombone player Julian Priester (born in 1935) started playing in his Chicago hometown with blues legends like Muddy Waters (McKinley Morganfield) and Bo Diddley. Focusing on jazz in the 1950s, he played with greats such as Max Roach, Dave Holland, and Sun Ra. He lived in San Francisco for six years in the 1970s before taking a position on the faculty at Cornish College of the Arts in Seattle. (Courtesy of Brian McMillen.)

Guitarist Kevin Eubanks (born in 1957) led *The Tonight Show* band for 15 years. He has recorded with such luminaries as Art Blakey, Dave Holland, and Jean-Luc Ponty. A fan of funk, blues, and jazz, he deftly infuses his compositions with the flavor of each, saying, "To me, it's all just music." (Courtesy of Brian McMillen.)

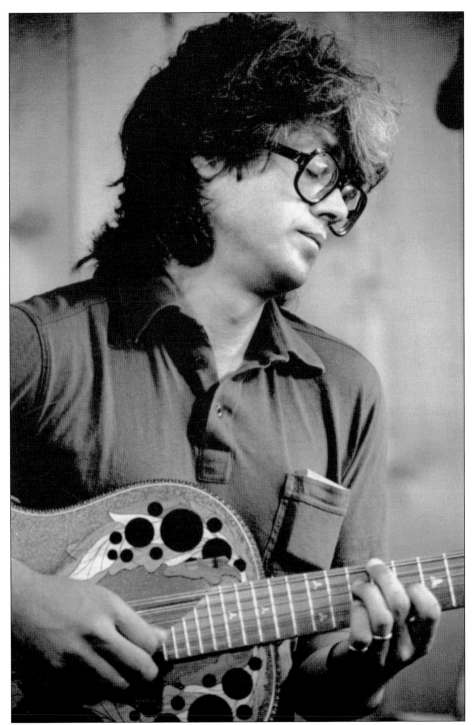

Larry Coryell (born in 1943), a preternaturally versatile guitarist known as one of the greatest, is comfortable across genres. He is adept at playing bebop as well as classical, blues, and rock, either acoustically or electrically. He says, "Over the years I hope I have become more of a musician and less of a guitarist." (Courtesy of Brian McMillen.)

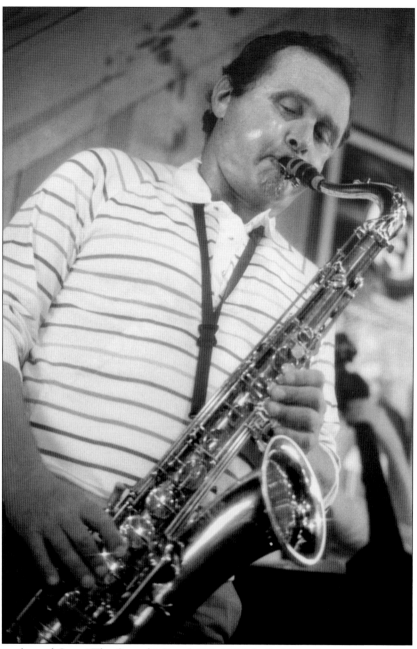

Saxophone legend Stan "The Sound" Getz (1927–1991) built his early reputation touring with Jack Teagarden, Stan Kenton, and Benny Goodman. As bebop jazz players found popularity by experimenting with modal jazz, Getz discovered bossa nova during an evening with Charlie Byrd, who had just returned from a Latin American tour. With João Gilberto and Antonio Carlos "Tom" Jobim, he recorded *Getz/Gilberto*, which won multiple Grammys. It includes Astrud Gilberto singing "The Girl from Ipanema." Getz is quoted saying, "My life is music, and in some vague, mysterious and subconscious way, I have always been driven by a taut inner spring which has propelled me to almost compulsively reach for perfection in music, often-in fact, mostly-at the expense of everything else in my life." (Courtesy of Brian McMillen.)

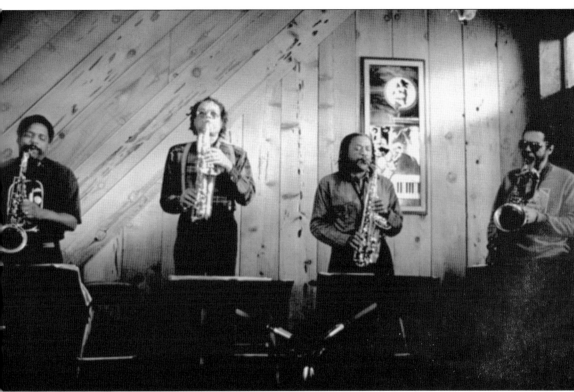

The World Saxophone Quartet, founded in 1977, originally featured David Murray on tenor saxophone, Julius Hemphill and Oliver Lake on alto saxophone, and Hamiet Bluiett on baritone saxophone. The group typically mirrored a classical string quartet with this instrumental scheme, though their style reflected African jazz elements along with free funk. The stained-glass panel on the wall behind the band originally hung in the First National Bank of Jazz in Seattle. (Courtesy of Brian McMillen.)

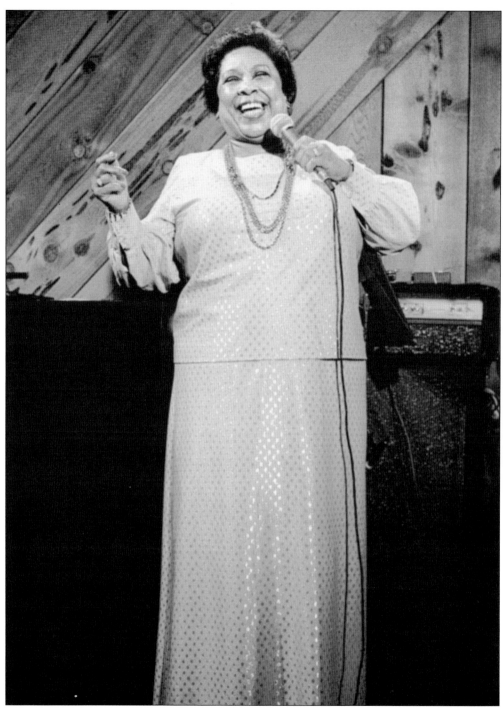

Helen Humes (1913–1981) belted out jazz and R & B tunes with apparent, palpable verve. Humes replaced Billie Holliday in 1938 in the Count Basie orchestra and recorded with the band for three years. A mid-career retirement to care for her ailing family ended in 1973 after her mother passed away, and she was asked to reunite with Count Basie at the Newport Jazz Festival. (Courtesy of Brian McMillen.)

BIBLIOGRAPHY

Bacon, Daniel. *Walking San Francisco on the Barbary Coast Trail*. San Francisco: Quicksilver Press, 1997.

bancroft.berkeley.edu/ROHO

Carr, Roy. *A Century of Jazz*. London: Hamlyn, 1997.

Clute, Peter, and Jim Goggins. *The Great Jazz Revival*. San Rafael, CA: Donna Ewald, 1994.

Coker, Jerry. *How to Listen to Jazz*. New Albany, IN: Jamey Aebersold, 1990.

Enstice, Wayne, and Janis Stockhouse. *Jazzwomen: Conversations with Twenty-One Musicians*. Bloomington: Indiana University Press, 2004.

federicocervantes.blogspot.com

Frisco Cricket, a publication of the San Francisco Traditional Jazz Foundation.

Gioia, Ted. *West Coast Jazz*. Berkeley: University of California Press, 1992.

Leigh, James. *Heaven on the Side: A Jazz Life*. Self-published, 2000.

Pepin, Elizabeth and Lewis Watts. *Harlem of the West*. San Francisco: Chronicle Books, 2006.

Shipton, Alyn. *A New History of Jazz*. New York: Continuum International Publishing, 2007.

Sloane, Kathy. *Keystone Korner: Portrait of a Jazz Club*. Bloomington: Indiana University Press, 2011.

Stoddard, Tom. *Jazz on the Barbary Coast*. Berkeley, CA: Heyday Books, 1982.

Wheaton, Jack. *All That Jazz!* New York: Ardsley House Publishers, 1994.

www.allaboutjazz.com

www.davebrubeck.com

www.foundsf.org

www.jazzhotbigstep.com

www.jazzwest.com

www.joelselvin.com

www.pbs.org/kqed/fillmore

www.sftradjazz.org

www.tshaonline.org

DISCOVER THOUSANDS OF LOCAL HISTORY BOOKS
FEATURING MILLIONS OF VINTAGE IMAGES

Arcadia Publishing, the leading local history publisher in the United States, is committed to making history accessible and meaningful through publishing books that celebrate and preserve the heritage of America's people and places.

Find more books like this at
www.arcadiapublishing.com

Search for your hometown history, your old stomping grounds, and even your favorite sports team.

Consistent with our mission to preserve history on a local level, this book was printed in South Carolina on American-made paper and manufactured entirely in the United States. Products carrying the accredited Forest Stewardship Council (FSC) label are printed on 100 percent FSC-certified paper.